IMAGES
of America

VASHON-MAURY ISLAND

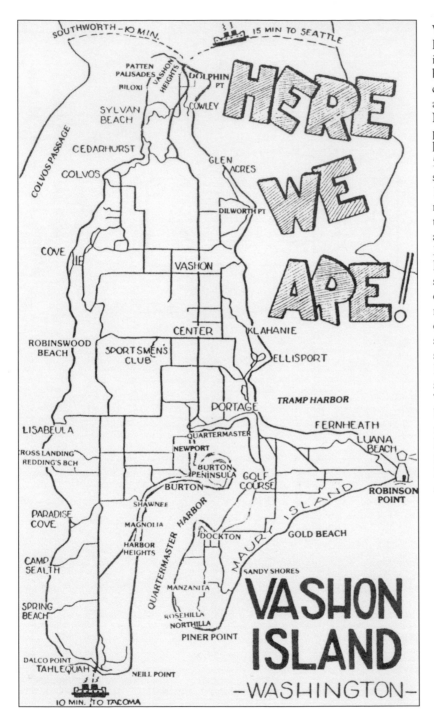

Vashon-Maury Island is nestled in Puget Sound between the cities of Seattle and Tacoma. Nearly 11,000 people call it home. With a 51-mile-long shoreline, it is 13 miles long, 8 miles across at the widest point, and approximately 37 square miles. Dotting the shoreline are the communities that recall the days of steamer stops, settlers' self-sufficiency, and leisurely summer stays by city folk. This postcard, based on a 1950s map, says it all—Here We Are! (Vashon-Maury Island Heritage Association.)

ON THE COVER: Agriculture was the most important economic activity on Vashon-Maury Island for 50 years, from 1890 to 1940, and strawberries were the most important crop. Strawberries loved the summer sunlight and the well-drained glacial soil, and great acreage was not required to provide profits for farmers. The cover photograph shows a farm at Vashon Heights in 1920, when the pickers were still local and were often family members. (Vashon-Maury Island Heritage Association.)

IMAGES
of America

VASHON-MAURY ISLAND

Bruce Haulman and
Jean Cammon Findlay

ARCADIA
PUBLISHING

Published by Arcadia Publishing
Charleston, South Carolina

Printed in the United States of America

Library of Congress Control Number: 2010940477

For all general information, please contact Arcadia Publishing:
Telephone 843-853-2070
Fax 843-853-0044
E-mail sales@arcadiapublishing.com
For customer service and orders:
Toll-Free 1-888-313-2665

Visit us on the Internet at www.arcadiapublishing.com

To Pamela Haulman and Gilbert Findlay

CONTENTS

ACKNOWLEDGMENTS

Research support, advice, photographs, and suggestions came from many quarters.

First, we express our gratitude to our eagle-eyed manuscript readers: Vic Aquino, Mary Jo Barrentine, Gilbert Findlay, Pamela Haulman, Ann Irish, Alice Larson, Michelle Marshman, Peggy and Gene Sherman, Barbara Steen, and Holly Taylor.

Off-island help came from individuals either on their own behalf or as representatives of numerous institutions: Mary Anderson, Berkeley Breathed, Nicolette Bromberg, James Cheever, Robert Fisher, Harvey Greenberg, Michelle Humphrey, Carolyn Marr, Andrea Moody, David Pitcher, Evan Robb, Nancy Silver, Meghan Tillett, and Grant Walker.

Still others read portions of the text, made comments, and/or added research: Patrick Christie, Tom Devries, Reed Fitzpatrick, Kevin Freeman, Mike Kirk, Yvonne Kuperberg, Miyoko Matsuda, Robin Paterson, Laurie Tucker, Royce Wall, and Dick Warren.

Without the support of the Vashon-Maury Island Heritage Association (VMIHA) and the use of its archive and stellar photographic collection, this book would not exist. Unless otherwise credited, all pictures are from the VMIHA. All of the authors' royalties from this book will go to the VMIHA.

Islanders Ruth Anderson, Brett Bacchus, Beth Bordner, Terry Donnelly, Rayna Holtz, Nancy Katica, Michael Lambert, Mary Macapia, Ray Pfortner, Thom Porro, and Virginia Schwartz also supported our insatiable need for pictures.

Leslie Brown, *Vashon-Maury Island Beachcomber* editor, kindly allowed us free rein in the newspaper's photographic archives and the use of those photographs.

Many other individuals and institutions lent us their photographs and have received full credit where these are used.

A very special thank you goes to Andrea Avni, our excellent and tireless indexer.

We were fortunate to have had not one but two editors at Arcadia Publishing, each attentive, supportive, knowledgeable, and filled only with praise for our efforts. Thank you, Donna Libert and Sarah Higginbotham.

We salute you all. Please know how grateful we are.

INTRODUCTION

This is the story of Vashon-Maury Island, told through photographs. A photograph is worth more than a thousand words because the captured image gives us a glimpse of what life, the island, and the individuals who helped shape our past looked like. Yet photographs have limitations. They capture a single moment in time but only the moment that the photographer and camera are present. The VMIHA is fortunate to have an archive of more than 6,000 images to draw from, supplemented by finds in many personal collections and other repositories. Consequently, this book attempts to provide insights into why the island has become what it is today.

In developing this short photographic history of Vashon-Maury Island, nine major patterns emerged.

First, the island shifts from being a group of separate, water-based communities scattered around the edge of the island and focused on Tacoma to being a single island community focused primarily on Seattle.

Second, the island transforms from an extractive resource-based economy based on the "big four" of logging, farming, mining, and fishing to a human resource economy centered on commuters, services, and retirees.

Third, the island is prisoner of the boom and bust cycles that characterize the economy of the Pacific Northwest. Each boom—the 1880s, the 1910s, the 1950s, the 1960s, the 1990s, and the early years of the first decade of the 2000s—has been followed by a downturn.

Fourth, the island has always had a problematic relationship with its water transportation, and it experienced a series of ferry wars that eventually led to the creation of a Vashon ferry district and the ultimate formation of the Washington State Ferry System. Conflict continues in the ongoing debates over fare increases, service reductions, and passenger-only ferries.

Fifth, the island has changed ecologically, from a primeval climax, western red cedar, and hemlock cathedral forest to an ecosystem significantly modified by the S'Homamish Indians to an island nearly totally denuded of trees by the 1920s to the partially reforested second-growth fir forest of today.

Sixth, the island has shifted from being almost exclusively white—the Japanese population at it largest was less than one percent of the total population—to a still predominately white but slightly more multicultural population where 6.4 percent of the residents are of Native American, Latino, Asian, or African American heritage.

Seventh, the island has shifted politically from a predominantly conservative Republican voting pattern shaped by Civil War Union veterans who were members of the Grand Army of the Republic and agriculture-based farmers and suppliers to a predominantly liberal Democratic voting pattern that is largely urban and professional.

Eighth, the island has its own "natives versus newcomers" attitude. To begin with, the S'Homamish were suspicious of outsiders, whether other native groups or Euro-Americans. Later, Southerners were not welcomed in a post–Civil War Yankee enclave, as settlers flooded into the region in the

1870s and 1880s. And so it has gone, the "in groups" and "out groups" shifting with the tolerations of each era. As each group becomes assimilated, another arrives and the process begins again.

Finally, there has always been a struggle between those who seek to develop the island and think in terms of the possible future and those who favor protecting the island and think of the future in terms of preserving the past.

By writing the story of Vashon-Maury Island thematically rather than strictly chronologically, perhaps the reader may better trace the evolution of the island's history.

One

A SENSE OF PLACE
TO 1865

Three elements—water (liquid and solid), earthquakes, and human imaginings—molded Vashon-Maury and continue to shape the island today.

About 16,000 years ago, the ice sheets of the Puget Lobe of the Vashon Glacier lay 3,000 feet thick over the land. As this glacier moved, it defined the form and topography of the island. The climate of Vashon is dominated by rain—lots of it. As island author Betty MacDonald proclaimed in her 1955 book *Onions in the Stew*, "It rained and rained and rained and rained. It drizzled—misted—drooled—spat—poured—and just plain rained."

Earthquakes are a part of life on Vashon-Maury. The slow subduction of the Juan de Fuca Plate under the North American Plate (about three centimeters per year) creates an area of seismic and volcanic activity with Vashon at its center. The region experiences almost daily minor earthquakes, but "big ones" occurred in 1949 and 1965.

Though one may think civilization began with European settlement, the Coast Salish S'Homamish occupied the island for at least 3,000 to 6,000 years. The S'Homamish, one of the precursor bands of the current Puyallup tribe, flourished for thousands of years with five permanent villages and numerous gathering sites on the island. They used the marine resources and modified ecosystems by such practices as the annual burning of meadows to encourage foods such as native blackberries and bracken ferns. The precontact Indian population of the island is estimated at about 650 S'Homamish. At the end of the 18th century, their culture was at its peak. It had established a balance with the resources available, and for millennia they were a successful and thriving people. However, all this was about to change.

First contact with Europeans came in 1792, when George Vancouver explored Admiralty Inlet and named Vashon's Island. A period of mutualistic and peaceful trade developed, lasting until the second contact in 1841, when Charles Wilkes and the US Exploring Expedition sailed into Puget Sound and renamed part of Vashon's Island as Maury Island.

The S'Homamish, the British, and the Americans all helped to create a sense of place—the Vashon-Maury Island that is known today.

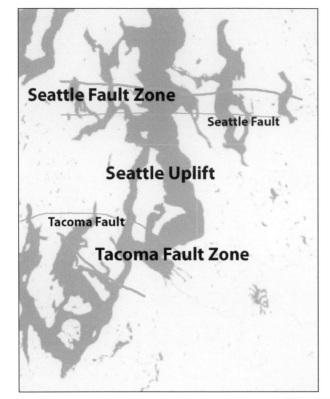

Seattle Fault Zone

Seattle Fault

Seattle Uplift

Tacoma Fault

Tacoma Fault Zone

Earthquakes are a part of life on Vashon-Maury Island, as the slow subduction of the Juan de Fuca Plate under the North American Plate creates an area of seismic activity with the Seattle uplift, which features the island squeezed between the Seattle and Tacoma faults. Landslides generate another hazard when slopes become supersaturated with water. Below, the rift created by just such a massive ancient slide along the west shore of Quartermaster Harbor can be seen. Over time, water trapped inside became Lost Lake. The dense clay also causes modern problems of septic-tank failure when the soil refuses to allow percolation. Water becomes a scarce resource when it is extracted at a faster rate than it can penetrate the clay layers into the deeper aquifers. (Left, Bruce Haulman from Kevin Freeman/Entrix; below, © Ray Pfortner/RayPfortner.com.)

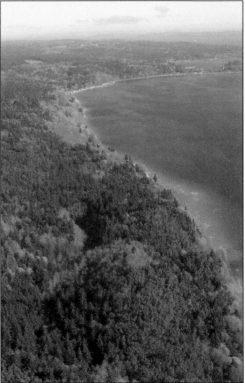

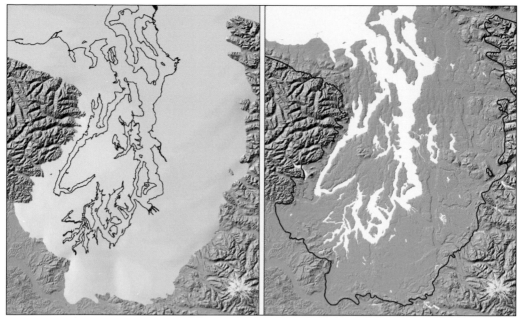

The most recent glaciation, 16,000 years ago, gouged and scoured the Northwest, creating the largely north-south lowland that is the Puget Basin. The Olympic and Cascade mountain ranges defined Puget Sound by funneling the advancing Puget Lobe of the Vashon Glacier between them and depositing the Vashon-Maury Island known today. A layer of relatively impermeable clay sits under a layer of sand from the glacial melt runoff, and massive accumulations of gravelly debris called Vashon Till sits on top—a combination susceptible to landslides. For the past 4,000 years, Vashon-Maury Island's warm, moist maritime climate has been relatively stable, producing the red cedar and hemlock forests that blanketed the region 150 years ago. Even today, hemlocks (below) prosper in the second-growth forests. (Above, Harvey Greenberg from Thorson and USGS data; below, Terry Donnelly.)

11

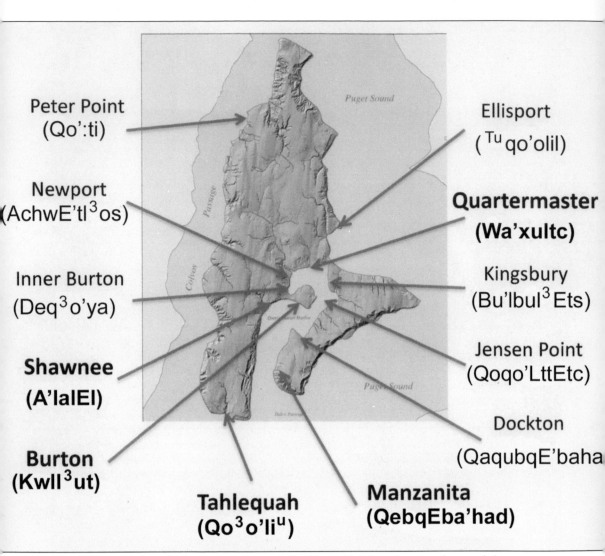

Peter Point
(Qo':ti)

Newport
(AchwE'tl^3os)

Inner Burton
(Deq^3o'ya)

**Shawnee
(A'lalEl)**

**Burton
(Kwll^3ut)**

Ellisport
(Tuqo'olil)

**Quartermaster
(Wa'xultc)**

Kingsbury
(Bu'lbul^3Ets)

Jensen Point
(Qoqo'LttEtc)

Dockton
(QaqubqE'baha

**Tahlequah
(Qo^3o'liu)**

**Manzanita
(QebqEba'had)**

The S'Homamish, which are members of the Coast Salish culture and one of the precursor bands of the current Puyallup tribe, flourished on Vashon-Maury Island for thousands of years. The precontact native population lived in five major village sites and numerous temporary gathering places. As seen on the map, the permanent villages were located at Burton, Shawnee, Quartermaster, Manzanita, and Tahlequah. The gathering places were at Assembly Point, Jensen Point, Kingsbury Beach, Newport, inner Quartermaster Harbor at Burton, Judd Creek, Ellisport, and Peter Point. Their homes were multifamily shed-roofed longhouses. Their diet was heavily dependent on fish, shellfish, and marine mammals, supplemented by root and nut carbohydrates. Their transportation was by canoe. Their villages were in protected locations close to these abundant resources. (Bruce Haulman from Kevin Freeman/Entrix.)

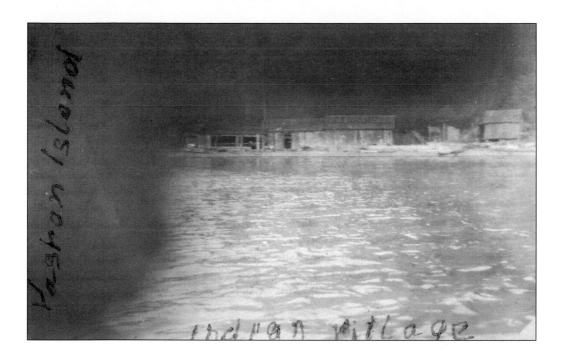

The primary S'Homamish village was at Burton, along the southern shore of the peninsula where Governor's Row is today. The only known photograph of a S'Homamish village is reproduced above. Tacoma artist Abby Williams Hill recorded the following in her diary on January 23, 1901, while staying at her Burton beach cabin: "There are Indians camping down the beach. Three families. They have a large space enclosed with mats and sheets, and from it little tents for sleeping. The women brought wool, which they spin on a stick with a wooden wheel crowded onto it. The men hunt ducks, go fishing, and above their fires are rows of herring smoking." She created this pen and ink drawing in February 1901. (Below, University of Puget Sound.)

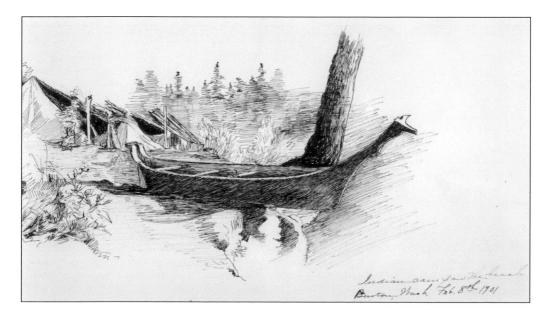

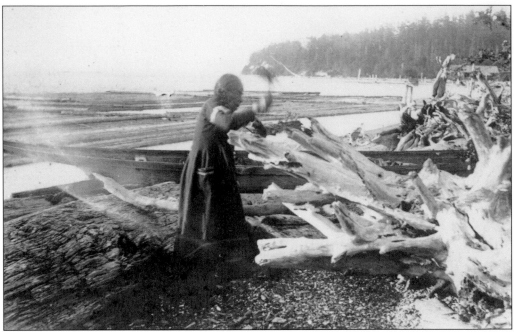

Taken by local photographer Oliver Van Olinda, these photographs represent typical scenes of native people from the 1890s: a woman collecting driftwood and a group outside their tent. The S'Homamish established some of the enduring patterns that still characterize Vashon-Maury Island, for they clearly saw themselves as an exceptional people yet distinctly tied to other groups throughout the Puget Sound basin by a complex series of marriages, affiliations, rituals, shared resources, and mutual defense. They also clearly defined themselves as "the people" on Vashon-Maury, and newcomers, although often welcomed, were distinctly outsiders. However, the cultural practices of living in extended family groups in longhouses, sharing food resources, and storing food in baskets made the S'Homamish particularly susceptible to European diseases, which killed more than two-thirds of their population by the 1850s. (University of Washington Libraries, Special Collections, above, UW19124; below, UW19115.)

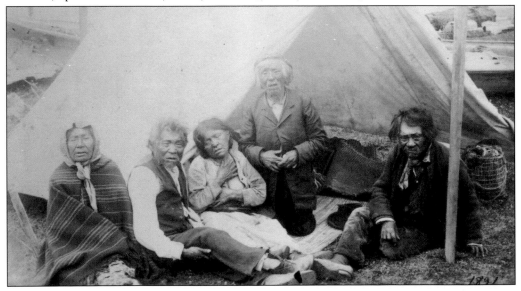

George Vancouver (1757–1798) commanded the *Discovery* on his expedition to America's northwest coast. He explored Puget Sound in 1792, naming 75 landmarks after colleagues and friends. On May 28, 1792, Vancouver named Vashon's Island for Capt. James Vashon, who previously commanded him, James Baker, and Peter Puget. (Borough Council of King's Lynn and West Norfolk.)

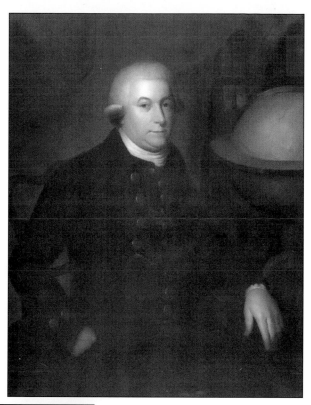

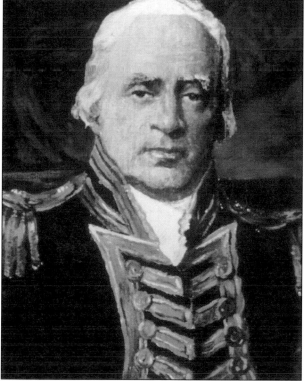

In 1755, at age 13, James Vashon (1742–1827) began his British naval service. He worked his way up through the ranks and was promoted to rear admiral in 1804, vice admiral in 1808, and admiral in 1821. In retirement, he lived in his native Shropshire, where he died at age 85 and was buried in the village of Ludlow. Vashon never saw the island that bears his name.

In 1841, forty-nine years after Vancouver, Comdr. Charles Wilkes and the US Exploring Expedition established American claim to the territory and gave new names to 261 places in Puget Sound. On Vashon, Wilkes named major points for his quartermasters, Beals, Heyer, Robinson, Piner, Neill, Dalco, and Sandford. He named the major harbor Quartermaster for all of them. Colvos Passage was named after Midshipman Colvocoresses. (US Naval Academy Museum.)

Maury is connected by a short isthmus to Vashon, though Wilkes recognized it as a separate island and named it after Lt. William Maury, the expedition's astronomer. A Virginian, Maury was commissioned in the Confederate States Navy when the Civil War began and commanded the raider *Georgia* and the ironclad *South Carolina* during the war. (US Naval Academy Museum.)

Two

SETTLEMENT
1865–1890

The Euro-Americans who settled Vashon-Maury Island between 1865 and 1890 quickly replaced the S'Homamish, and within 25 years they established the pattern for community, society, transportation, business, and discrimination that has influenced the island ever since. These years were transformative for both the Pacific Northwest and the island. When railroads arrived, settlers flooded in, Washington became a state, extractive resource-based economies thrived, and the major cities of Seattle and Tacoma grew exponentially. Vashon-Maury—lying between these two metropolitan centers and tied to them by the water link of Puget Sound steamers (the mosquito fleet)—experienced a similarly dramatic growth.

Access to saltwater and the protected shores of Quartermaster Harbor focused most of the first settlements into the southern two-thirds of the island and made Tacoma the primary mainland city.

By 1890, the pattern for social development of the island was well established, with churches, organizations, and schools all in place. The separate and distinct settlements on the island were water based and would define the identity of islanders during the next half-century. Burton, Ellisport, Lisabeula, Cove, and Dockton prospered with stores, post offices, docks, and residences.

The fundamental economic structure of the island's four primary industries dominated into the early 20th century. In addition, the industrial development at the shipyards and drydock at Dockton, the emerging summer tourist economy (focused originally around Chautauqua assemblies at Ellisport), and the growing retail centers completed the economic picture.

Discrimination has always been an unfortunate subtheme in Vashon's history, and by 1893, a pattern of discrimination was already in place. The internment of the S'Homamish in 1855 and the disappearance of the Chinese in 1888 represent the beginnings of discriminatory practices, the echoes of which can still be heard.

Matthew Bridges (pictured left at age 87 at Tahlequah) was the first permanent settler on Vashon-Maury. He came in 1865, filed a land claim at Cove, and lived on the island until his death in 1926 at age 98. Bridges has not generally been recognized as the first settler because he married an Indian, was not a Civil War veteran, and was a logger who moved frequently, thus foreshadowing the island's mobile working class.

The first farmers on the island were Salmon and Eliza Sherman (pictured below at their first home, which they named Fort Necessity). They moved to Vashon-Maury in 1877, continued to farm until Salmon's death in 1914 at age 77, and are generally viewed as the founding family; their descendants still live on the island. They represent the island farmers who became the solid middle class that has dominated island society and politics up to the present.

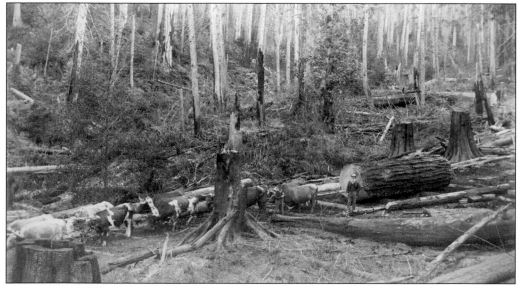

Beginning in 1852, logging was the first significant business on the island. Although it was an important first industry, its peak was not reached for another 20 years, and the last logging of old-growth forests ended in the late 1940s. The Hofmeister oxen team (above) cleared the Vashon College site in August 1892. Easily accessible clay deposits along the shorelines made clay mining and brick making another significant early industry. At one time, there were as many as 10 to 12 brickyards, including the Bleeker Brickyard in Burton (below). The growth of Seattle and Tacoma, a series of fires in Tacoma during the 1880s, and the great Seattle fire of 1889 all provided a market for bricks and drove the development of this industry.

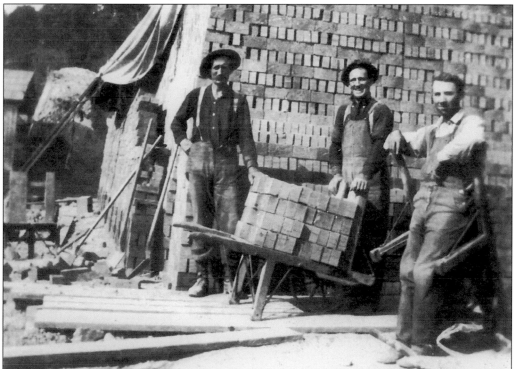

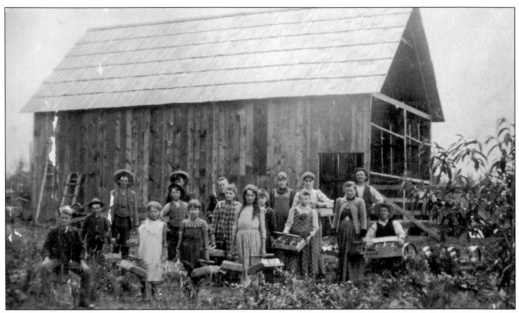

Agriculture was another significant early economic activity on Vashon-Maury Island, as typified by these strawberry pickers at the Thompson farm on July 4, 1893. By the early 1890s, more than half of the island's employed residents worked in agriculture. This dominance continued well into the agricultural depression of the 1920s, when the population began to decline. Today, it has its remnants in specialized and subscription farms. (University of Washington Libraries, Special Collections, UW19092.)

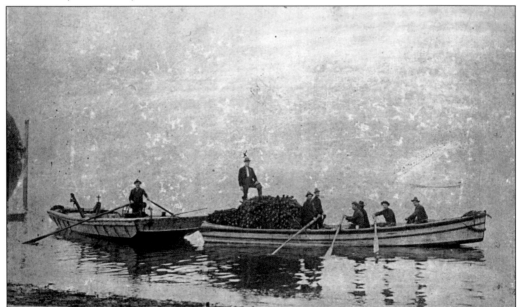

These fishing dories on Quartermaster Harbor (pictured in 1889 with Frank Berry standing on the nets) illustrate another prime business that reached its peak in the first decades of the 20th century. Early settlers fished as a chief subsistence activity, using, as did the S'Homamish before them, salmon, bottom fish, and shellfish as important parts of their diets. (University of Washington Libraries, Special Collections, UW19404.)

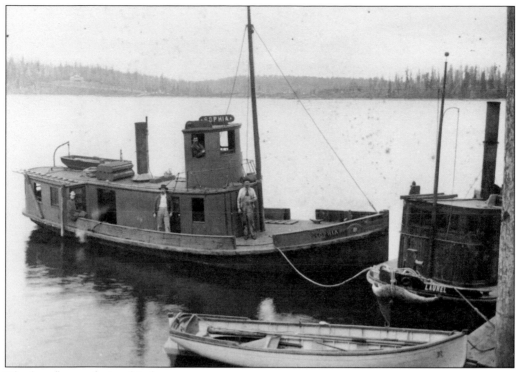

The love/hate relationship between islanders and their ferry service is one of the striking continuities in island history. The first regular service started in 1883 when the *Swan*, a 32-foot steam launch, began a twice-a-week schedule to Tacoma from Burton. In 1890, Frank Bibbins began the first daily service with the 42-foot *Sophia* (above). The Quartermaster Harbor brickyards and mill gave considerable business to the little steamer.

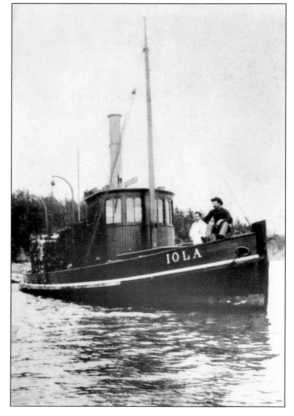

Until 1887, Thomas Redding (on the bow) skippered the *Iola*, which was then sold to Capt. John Vanderhoef, who, by 1889, was making six round-trips per week from the west side of Vashon to Tacoma and Seattle. The *Iola* stopped at all the docks and would also pick up passengers or freight anywhere, even if rowed out in a dingy. (Robin Paterson.)

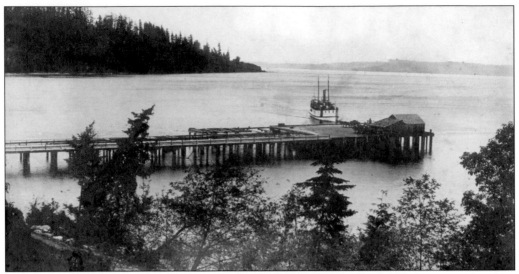

Vashon Landing (pictured above around 1901 with the *Defiance* approaching) was located at the end of Soper Road and was an important early steamer dock, having a post office, a store, and easy access to the growing farms, which shipped an average of 400 berry crates daily in 1895 alone. In 1884, the Lighthouse Service purchased 24 acres at Point Robinson for a fog signal that was dedicated on July 1, 1885. A kerosene red light on a 25-foot pole was added in 1887 and used until an open tower was built in 1894 (below). A log bulkhead, built to stabilize the beach and the mudflats, cut the tidal marsh in half, and by 1914, the Lighthouse Service had washed down the hillside, which filled the marsh and created the point. (Below, National Archives, 26-LG-62-44.)

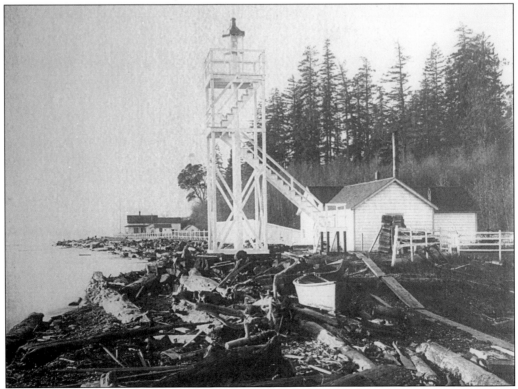

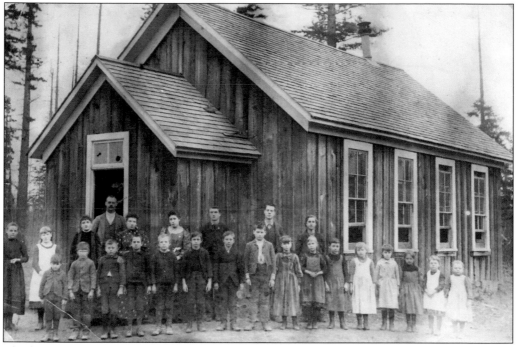

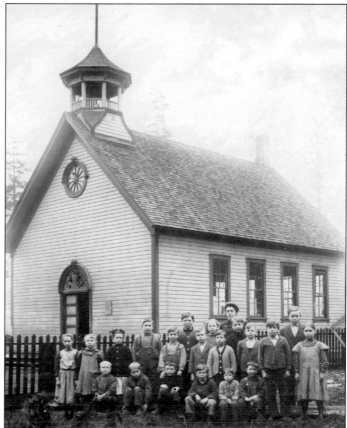

The first school, taught by Julia A. Judd, was built at Center in 1881. In 1882, separate districts opened schools at Quartermaster and Vashon. The first schools were rough cabins, but by 1887, the 18-by-28-foot Vashon School at what is now Ober Park (above) was board and batten with painted window frames and a cedar shingle roof. By 1892, there were also schools at Burton, Columbia (at Cove), Mileta, Portage, and Southern Heights. The Vermontville School (right) was built in 1892. In 1911, the Vermontville and Vashon school districts merged. In 1912, they began constructing Vashon High School on the main highway north of the town of Vashon, where Harbor School is today. (Right, University of Washington Libraries, Special Collections, UW19303.)

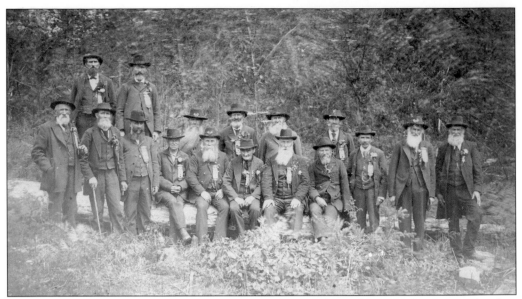

A number of social organizations helped create the interdependent social structure that has characterized the island since early settlement. In 1888, the Independent Order of Grand Templars built a large meeting hall, and a Women's Christian Temperance Union chapter was established. In 1890, with 16 Civil War Union veterans as charter members, H.G. Sickles Post No. 57, Grand Army of the Republic (pictured above in 1895) was founded. That same year, a women's branch called the H.G. Sickles Corps No. 37, Women's Relief Corps, and a Sons of Veterans, General Wadsworth Camp No. 29, were also organized. Together, these three organizations helped define the island as an enclave for Union Civil War veterans. Typical of gatherings during this era, pioneer picnic-goers (below) are dressed in their Sunday best, including a long, accordion-pleated apron.

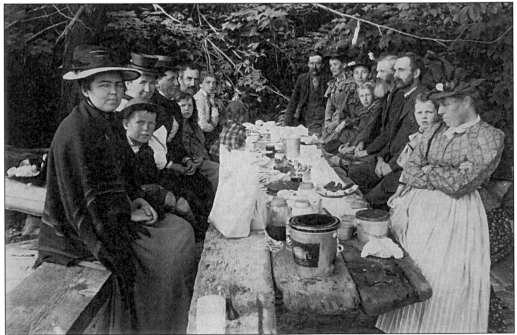

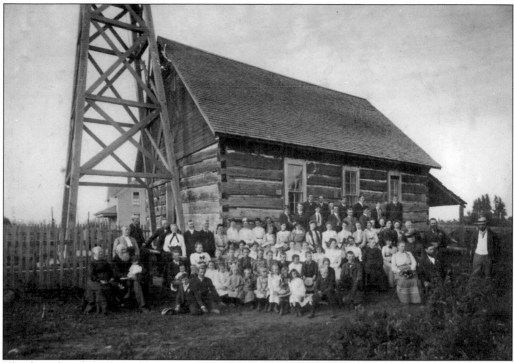

The first church built on Vashon-Maury Island was the log Methodist church at Vashon town in 1885. In 1908, the present Methodist church was built, and the old building was used for Sunday school and meetings until it was demolished in 1948.

John T. Blackburn (with his wife, Jerusha, and children Carrie, Lester, and Hattie) was appointed Vashon's first postmaster in 1885 and notary public in 1887. He was elected representative for the 1888 session of the territorial legislature, which never assembled because of the constitutional convention that formed the state of Washington. He became the first elected official to represent Vashon-Maury Island in the 1889 Washington State Legislature.

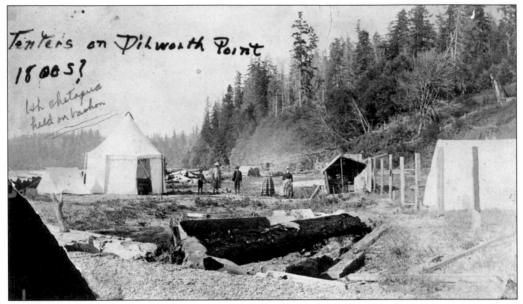

Tenters on Dilworth Point 1885?
1st chataqua held on vashon

A tourist economy began early, and the most important development during this era was the emergence of the Chautauqua movement, which held the first Puget Sound Chautauqua Assembly meeting at Dilworth Point in 1885 (above). In 1888, Chautauqua returned to Vashon, choosing the area that would become Ellisport for its assembly grounds. Platform tents (below) were used before permanent structures could be built. The movement was a summertime presentation of lectures, discussions, and cultural activities in a resort atmosphere. Advertisements promised that "families may escape the noxious vapors and the immoral influences of a crowded city and combine health, instruction, and pleasure." In 1889, organizers offered campfires, excursion cruises, clambakes, concerts, art instruction, and lectures on the zoology of the Bible, Greek customs, temperance, and natural history.

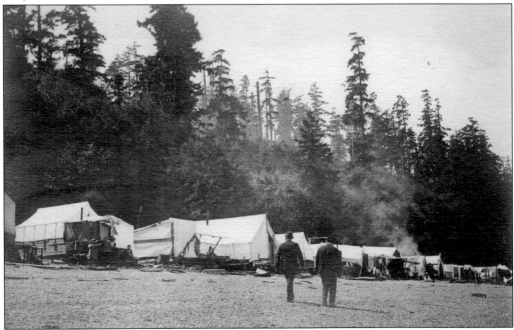

The Richard Dilworth home (above, 1884) exemplifies the simple structure of early dwellings built with available timber and covered in shakes. More elaborate and substantial clapboard houses quickly followed. Stores were more substantial from the beginning. In 1884, the first store on Vashon was built near the corner of Southwest 188th Street and 96th Place Southwest by Loren Anway and John McLean, who moved the business to Center (below, 1890), where the building still stands on the northwest corner. George Fuller built the second store at Ellisport and moved it to Center in 1885. With these two stores, the first school, and a church, Center was the largest inland community on the island. In 1890, Frank Gorsuch opened the first store at what would become the town of Vashon, which quickly eclipsed Center as the inland commercial hub. (Above, University of Washington Libraries, Special Collections, UW19138.)

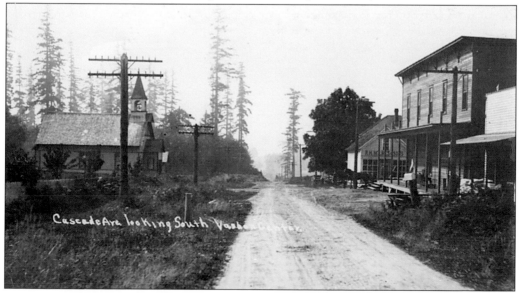

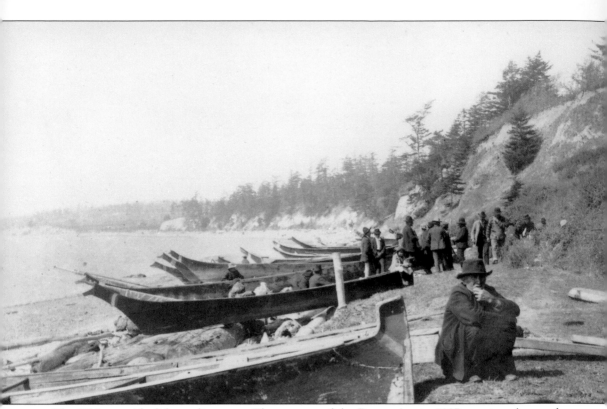

The S'Homamish did not disappear. The passage of the Dawes Act in 1887 continued to push Indians onto reservations, then broke reservations into individual allotments to encourage assimilation into white culture. This act and the growth of white settlement encouraged the remaining S'Homamish to move to the reservation at Tacoma. Though their old culture was shattered, customs died hard, and reservation S'Homamish continued to visit the island to hunt and fish at their accustomed sites. Some eventually lost or sold their allotments and moved back to their island home. They remained loyal to place and developed ways of surviving in the white-dominated world. This undated Oliver Van Olinda photograph of Puget Sound natives captures the blending of the modern (their clothes) and the traditional (their canoes). (University of Washington Libraries, Special Collections, UW19108.)

Three

BOOM
1890–1920

Between 1890, when the pattern for future development of the island was initiated, and 1920, when it was fixed, Vashon-Maury moved from a scattering of logging operations, homestead farms, and emerging villages to an island of numerous well-established, self-identified, water-based communities beading the shoreline. By 1920, the settlement era was over. The island experienced tremendous population growth, increasing from 514 residents in 1889 to 2,337 in 1920. Vashon College was founded in 1892 at Burton, prospering until a disastrous fire in 1910 led to its closure. Industrial development peaked and slowly declined as the drydock at Dockton flourished and then moved to Seattle, leaving only the shipyards that continued to build and repair vessels into the 1920s. The island was well on its way to becoming a predominantly agricultural and residential hinterland for the urban centers of Seattle and Tacoma.

Island boosterism imagined a canal at Portage and an electric streetcar. New subdivisions were platted at Harbor Heights, Vashon Heights, and Glen Acres, and the new technologies of electricity, automobiles, and telephones came to the island. With the proliferation of automobiles, roads began to connect communities. Vashon State Bank was formed, and tourism continued to be a significant summer influence on the island, with the opening of numerous resorts and camps.

Local communities, with their individual school districts, dominated island life. Reliance on the steamboats of the mosquito fleet on the "liquid highway," which characterized the island since the first settlement, began a tectonic shift toward paved highways and automobile ferries at both ends of the island. This also involved a move toward ferries operated by governments and away from entrepreneurial owner-operators.

Finally, a series of state and national efforts began to slow and ultimately end Japanese immigration, and a state law was passed in 1920 to limit Japanese land ownership. This was part of a larger change in American culture in which the nation of immigrants began to close its doors to the peoples who had populated it.

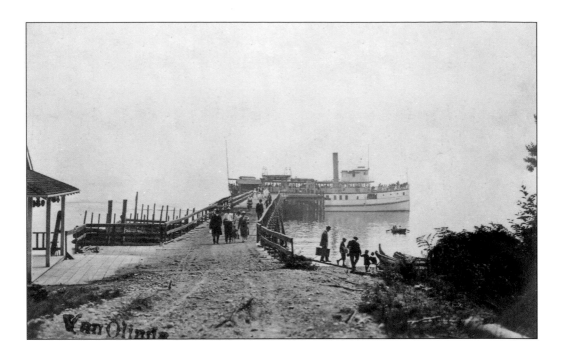

Separate, self-identified, water-based communities such as Glen Acres (above, page 30, with the *Daily* at the dock) established their individuality by developing stores, post offices, resorts, churches, and clubs. But Vashon town slowly emerged as the dominant economic center when roads improved and automobiles became more popular. Ultimately, these local stores, churches, and post offices closed, and with them the strong community identity of these places diminished. Each community created an ethnic identity that was reinforced by chain migration, in which relatives, neighbors, and friends followed the first immigrants. Historian Richard White observed that settlers were "far more concerned with re-creation than with creation. The goal of the transformation . . . was ultimately the restoration of the familiar world they had left behind." Scandinavians populated Colvos and Cove (above, page 31, with the Rindal store), Dalmatian-

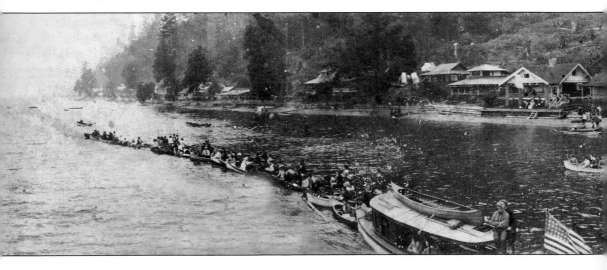

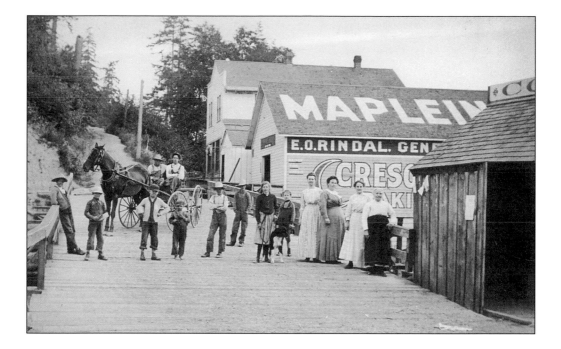

coast Austrians (modern Croatians) settled Dockton, and migrants from New England formed Vermontville. Community identity was maintained in part by columns in the weekly newspaper, which reported the activities, visitors, and news of the area to the rest of the island. Visits between communities were rare until roads became better developed. Until the 1920s, it was easier to get from Cove to Ellisport by catching a steamer to Tacoma and then another steamer to Ellisport than it was to try and make the journey across the island. The Magnolia Beach community's annual water carnival (below, taken from the Magnolia dock in 1915) featured a day of swimming, diving, singing, homes decorated with Japanese lanterns, and a magnificent boat parade. (Above, page 30, University of Washington Libraries, Special Collections, UW19219.)

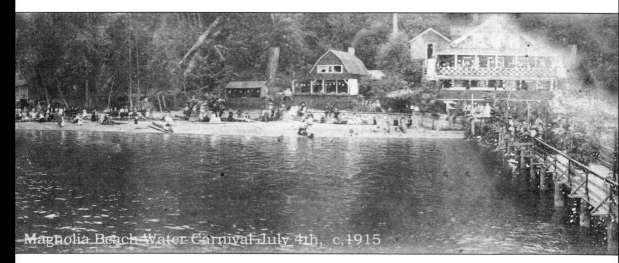

Magnolia Beach Water Carnival July 4th, c.1915

The decade between 1906 and 1916 marked the peak of logging on Vashon-Maury, when more than one-third of the island was intensively logged. Afterward, it took 60 years before the second-growth forest substantially recovered. It will take 10 times that, another 600 years, before the old growth cathedral forests that once blanketed the island might be reestablished. One successful logger was Hilmar Steen. His first mill, just north of Vashon town, operated from 1900 to 1907. He then moved to a location on what is now Cove Road (above), where he built a considerable Craftsman-style house, a small logging railroad, and a mill that he operated until 1923. From 1923 to 1932, Steen had a mill at Ellisport, which was later bought by the Fullers. Shake mills were another important part of logging. The shake bolt wagon (below, page 32) delivered cedar

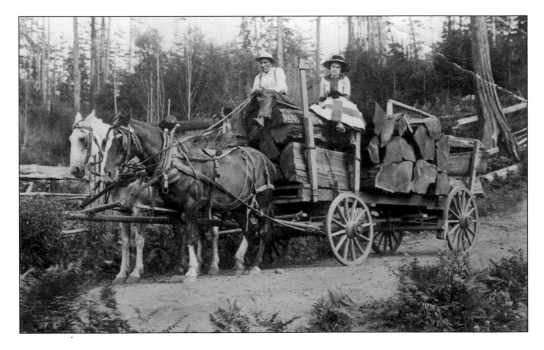

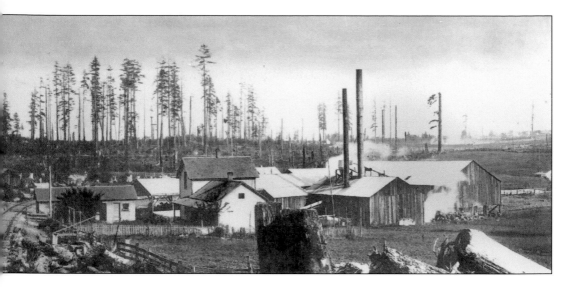

bolts to be split into shakes for roofs and siding. Mining for gravel and clay also peaked by the beginning of the 20th century. With the end of the building boom in Tacoma and Seattle following the depression of 1893, the brick factories on the island quickly disappeared, and the remaining mines primarily extracted gravel for local use. Remains of these mines can be seen on land at High School Hill and Pohl Road and from the water at Vashon Landing, Robinswood Beach, Corbin Beach (below, page 33, with a flume transporting gravel to bunkers for sorting), Biloxi Road, and south of Point Robinson, where Gold Beach is a reclaimed gravel pit. The Glacier site was active, serving mostly local needs.

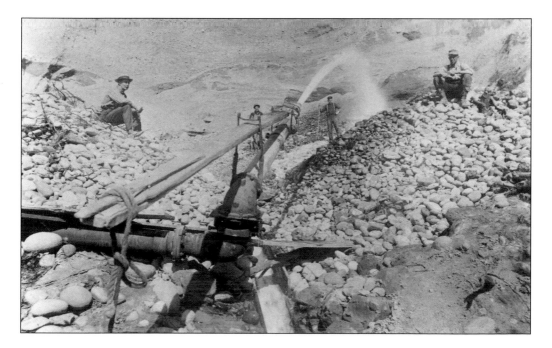

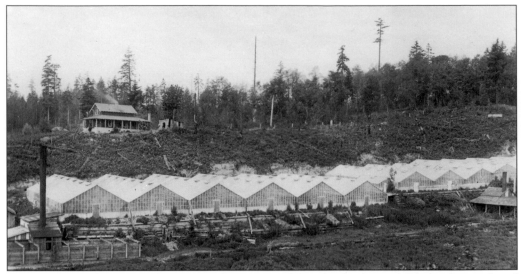

As a supplier to the metropolitan areas of Tacoma and Seattle, the demand for island agricultural products increased dramatically as these cities grew. By the mid-1890s, greenhouses operated by Charles Newcom (above, at Ellisport), George and Verne Covey, Warren Gordon, Hilen and Clinton Harrington, Charles Griswold, Hiram Fuller, and Paris Nye supplied vegetables to these markets. By 1900, the 1893 depression was over and agriculture led the recovering economy. Strawberries became a primary crop, with 165,000 crates shipped in 1910. Denichiro "D.B." Mukai, (below, far left, in his field shed wearing a bowler hat) developed a cold-packing process that allowed berries to be shipped across the country. The Horticulture Society sponsored the first Island Fair in 1901, beginning the tradition of annual island festivals.

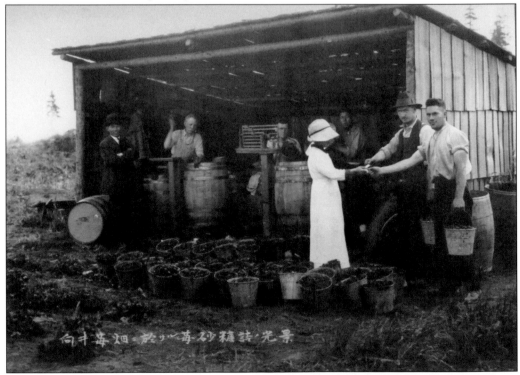

向井苺畑ニ於ケル苺砂糖詰ノ光景

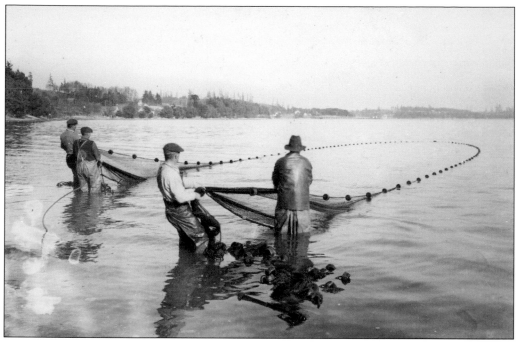

Puget Sound salmon fishing reached its peak in 1914. For herring fishermen such as these at Dockton (above, in a Norman Edson photograph), the runs in Puget Sound and Quartermaster Harbor provided an accessible resource that was quickly overfished, ultimately pushing fishermen farther north to follow the salmon runs into southeast Alaska or forcing them out of fishing as a primary occupation. The peak and collapse of island fishery meant the opening and closing of canning plants at Vashon Landing and Dockton in a typical extractive resource boom-and-bust cycle. Meanwhile, the S'Homamish, like Tom Gerand (below, left, at Quartermaster Dock), continued to dig clams. He shipped them by steamer, such as the *Vashon* (seen below at the dock), to sell in Tacoma.

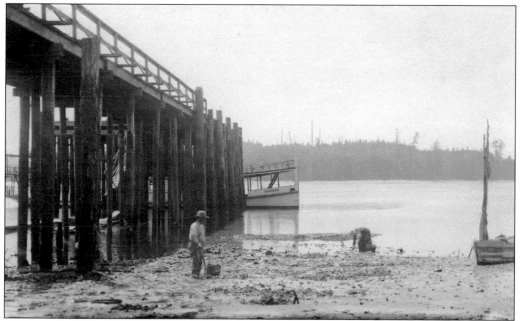

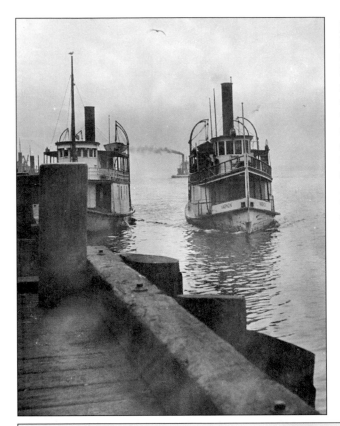

Four "ferry wars" took place between 1890 and 1920, when the introduction of car ferries began the long, slow death of the mosquito fleet. Any steamer that challenged another's supremacy would be taken on. Pictured at left are the *Defiance* and a competitor at Burton around 1901. The first ferry war was on the west side between Thomas Redding's *Iola* and John Vanderhoef's *Glide*. The second was fought in Quartermaster Harbor between the *Burton* and the *Vashon*. The third was fought in West Pass between Nels Christiansen's *Virginia* boats (below, the *Tyrus*, later the *Virginia IV*, at a float flag stop) and the *Sentinel*. The fourth was fought between the auto ferry at Portage and the auto ferries at Vashon Heights and Tahlequah. King County ultimately abandoned the Portage–Des Moines route in favor of ferries at both ends of the island.

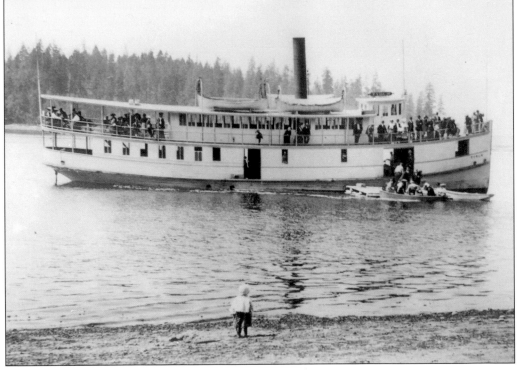

VASHON-MAURY FERRY ELECTION

DECEMBER 4, 1915

Mark X in Square Before Ports Between Which You Wish Ferry to Operate.

VOTE FOR ONE		VOTE FOR ONE	
☐	VASHON HEIGHTS	☐	SEATTLE
☐	VASHON	☐	THREE TREE POINT
☒	NEAR PORTAGE	☒	DES MOINES

NOTE---If Property Owner and Not a Voter on Vashon or Maury Island, state location of your property.

Vashon-Maury Island sought an auto ferry connection to the mainland, and in late 1915, it voted to have King County locate the route at Portage on Vashon and at Des Moines to connect to the new brick Des Moines Highway. The county launched the 115-foot diesel ferry *Vashon Island* (below) in 1916 for the new run. The ferry made six trips each day and cost 10¢ per person—the lowest rate on Puget Sound. By building the ferry and connecting the run to a county road, King County established the precedent of ferry routes as marine highways. In 1919, King County opened a ferry from Vashon Heights to Seattle, and in 1920, Pierce County initiated the ferry from Tahlequah to Point Defiance. This competition led to the closing of the Portage route in 1921. (Below, Puget Sound Maritime Historical Society, 4382.)

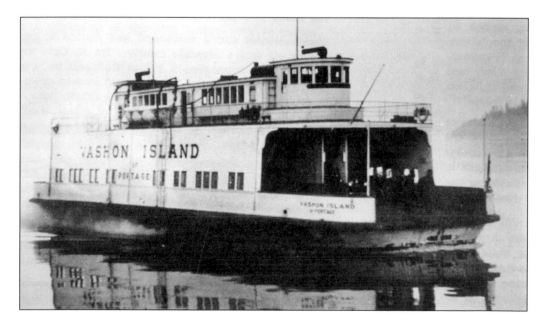

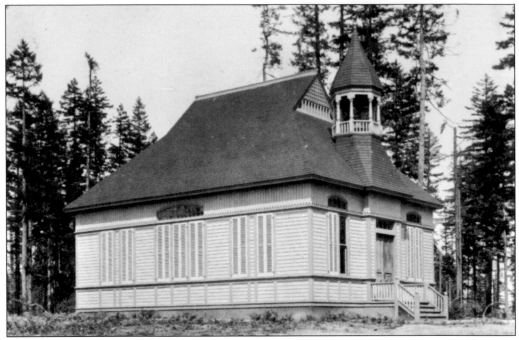

Most of the schools built between 1890 and 1920 were small one- to three-room buildings for grades one through eight. The first log schoolhouse at Center was torn down and replaced by a better two-story building. Many schools were superbly constructed, such as Quartermaster School (above), a Victorian structure built in 1888 on Morgan Hill and described as the most beautiful in the state. A year earlier, Vashon School was built at Vashon town. The replacement Vashon School (below), built in 1908, later served as the Island Club well into the post–World War II era, when it was demolished to make way for the new library and Ober Park. The first attempt to unite the school districts on the island began in 1908, but it was another 35 years before Vashon had a single school district.

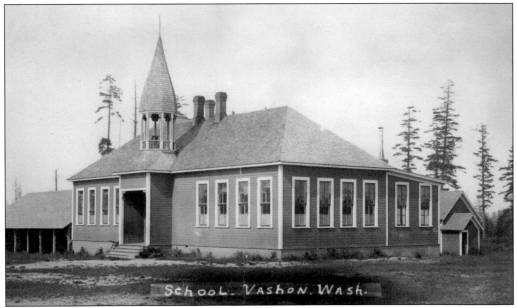

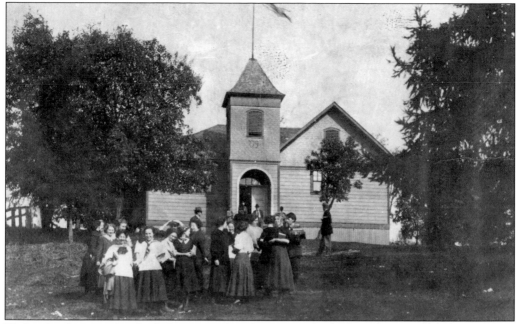

High schools opened at both Burton and Vashon as the number of students rapidly grew. The first Burton High opened in 1908 (above, 1910) on Burton Peninsula. Vashon High (below, 1913), a magnificent three-story brick building, was built north of Vashon town in 1912 (at the current site of the Harbor School); a gymnasium was added seven years later. While independent districts were at their height, this was also the beginning of consolidation. The southern Vashon districts and Maury districts joined to become the Unified J District and moved Burton High School from Burton Peninsula to a new two-story brick building on the south side of Judd Creek in 1913. Consolidations continued another 30 years until Vashon had a unified school district for the entire island.

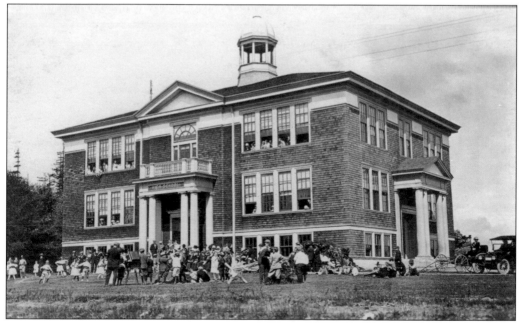

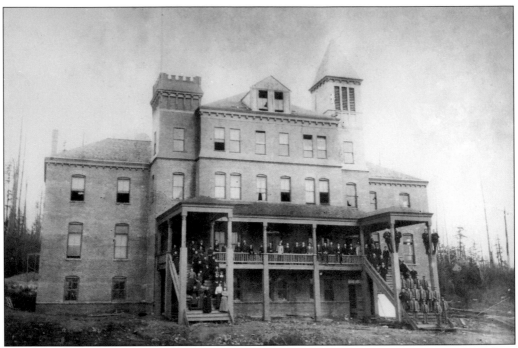

Vashon College opened in "Old Main" (above) on Burton Hill on October 25, 1892. The college founders believed that "coeducation and Christian instruction . . . free from all trace of sectarian lines, are important factors in modern education." The first year, 78 students enrolled, paying a fee of $165.50 each. The future for Vashon College looked bright, as the catalog bragged, "There are no saloons, gambling houses, dancehalls or other places of evil influence within eight miles of Vashon College." Forming the campus in the photograph below are, from left to right, Old Main, Commercial Hall (1894), and the Armory (1901), which was then the largest drill hall in the state. In 1910, Old Main burned and was almost a total loss. The fire effectively ended Vashon College for nearly a century. It was revived in 2007. (Below, Robin Paterson.)

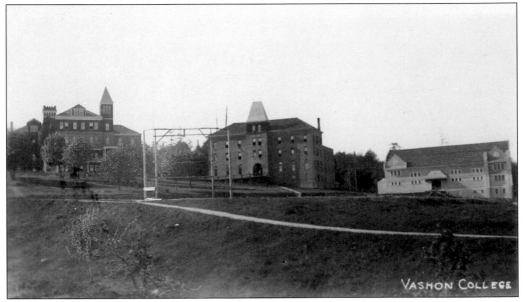

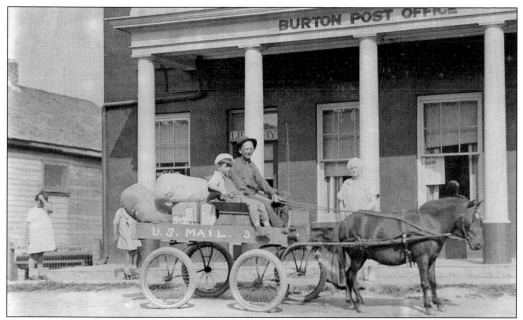

Post offices were located in 16 communities. This included the one at Burton (above, 1920s), where driver Amos Cummings brought the mail from the steamer at Burton Dock to postmistress Augusta Hunt (right). But many began to close when Rural Free Delivery (RFD) was instituted on the island on June 15, 1905, and Fred and Frank Kingsbury (Frank, below, in his Model T, 1910) began delivery. Of the original post offices, Vashon (1883) is the only one surviving to the present day. Others were at Chautauqua/Ellisport (1888–1943), Maury (1888–1912), Quartermaster/Burton (1890–1974, when it became a substation of Vashon), Aquarium (1892–1909), Lisabeula (1892–1935), Dockton (1903–1979), Portage (1903–1968), Cove (1904–1956), Colvos (1905–1910), Cedarhurst (1912–1919), Raeco/Racoma Beach (1907–1911), Magnolia (1908–1953), Spring Beach (1913–1943), Glen Acres (1914–1918), and Luseata Beach/Camp Sealth (1916–1950).

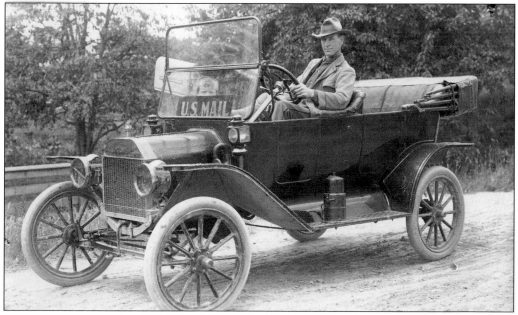

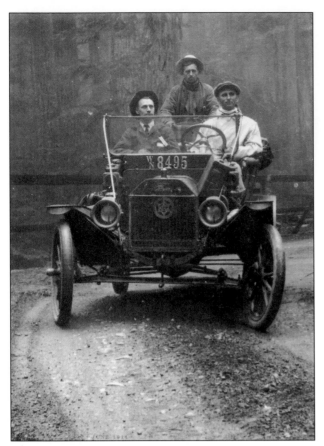

The arrival of the first automobile on the island in 1907 spurred road construction and encouraged touring, as in the photograph at left from 1914. Posing at Mount Index in Terkel Hansen's Model T are, from left to right, Charles Van Olinda, Henry Weiss, and Hansen. In the 1880s, King County built the first roads from Burton to Center and two east-west roads. The network expanded with a water-level road across Portage in 1897, which finally connected to Dockton in 1924. The road along Tramp Harbor was constructed in 1916 to accommodate the Portage–Des Moines ferry. A road was built from Burton to Shawnee-Magnolia in 1913–1914 and was extended south to Tahlequah in 1932. The King County Council staged the photograph below (looking north in Vashon's main intersection) in 1915 while on a Good Roads tour. (Left, University of Washington Libraries, Special Collections, UW19393.)

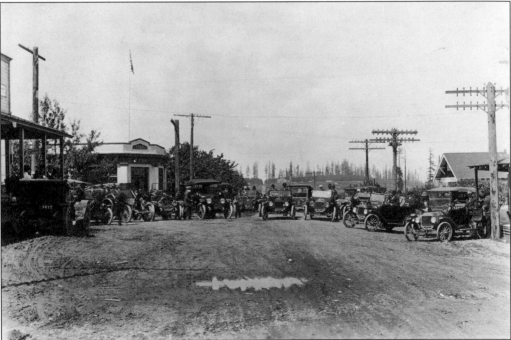

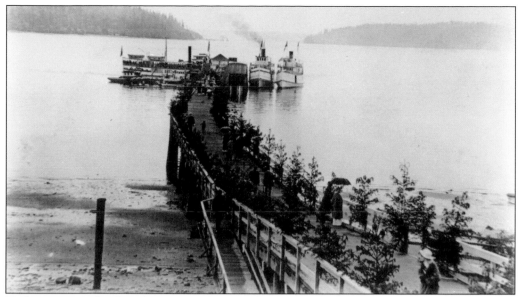

Vashon-Maury Island's isolation was a boon to the developing tourism and recreational economy. Strawberry Festivals—like this one held at Burton (above, 1915) with three steamboats disembarking visitors—promoted the island, as did residential developments. Magnolia Beach was platted in 1902, Spring Beach in 1903, Harbor Heights in 1906, Vashon Heights in 1909, and Glen Acres in 1910. Each of these communities had its own store, dock, and post office. The island was viewed by many as a refuge from urban Seattle and Tacoma. Private cabins, like Idle Hour at Spring Beach, and destination resorts were both popular. Among others, Frank Hubbell built Luana Beach resort in 1918, and Swastika Lodge north of Glen Acres opened in 1920 when a swastika was still just a Native American symbol for wellbeing.

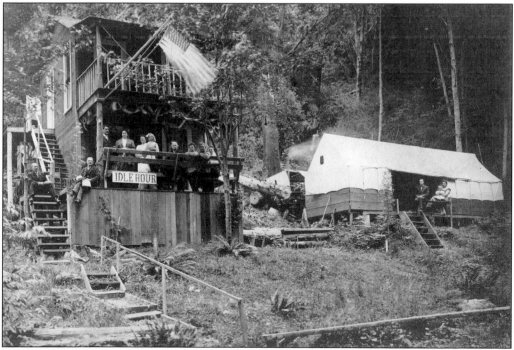

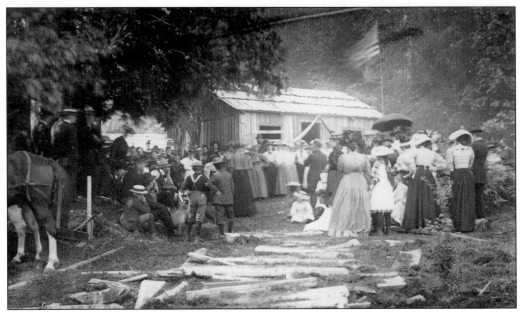

The most important tourist development was the Chautauqua movement at what would become Ellisport. On May 24, 1888, the Puget Sound Chautauqua Assembly platted Chautauqua Beach. This was the first town platted on the island. It had roads named for such American writers as Bryant, Emerson, Lowell, Hawthorne, and Irving; for native trees such as Alder, Fir, and Cedar; and for inspirational concepts like Olympus and Prospect. The 1896 Fourth of July celebration (above) demonstrated that Chautauqua offered escape from "the noxious vapors and immoral influences of a crowded city" as well as educational and spiritually inspirational programs. Eventually, the site grew to 600 acres, with two miles of shoreline, a dock, a hotel (below, on the hill), dozens of cottages, a 1,200-seat amphitheater, and a three-story pavilion at the water's edge. (Above, University of Washington Libraries, Special Collections, UW18697.)

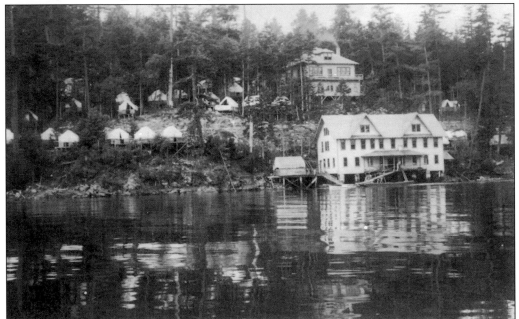

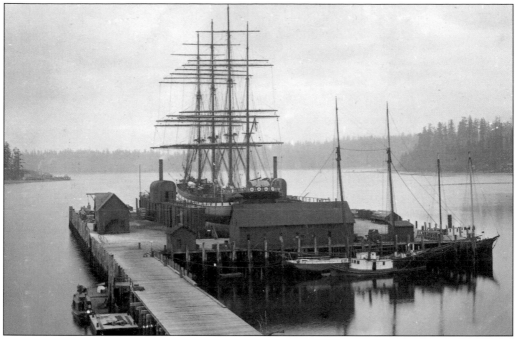

Quartermaster Harbor was an industrial center with brickyards, lumber mills, several shipyards, and a drydock. In November 1891, the still unfinished drydock was towed from Port Hadlock to Dockton, where it was completed. At 102 feet wide by 325 feet long, pictured with the steel, four-masted, 326-foot bark *Olivebank* inside (above, 1893), it was the largest drydock west of the Mississippi. As the drydock business grew, so did the town. A large, three-story hotel to house workers (below, far left), a series of homes for the managers called Piano Row, and a store were built. Regular steamer service to Tacoma and an active fishing fleet made Dockton a thriving community. In 1908, the drydock was sold and moved to the Duwamish River in Seattle. (Above, University of Washington Libraries, Special Collections, UW19277.)

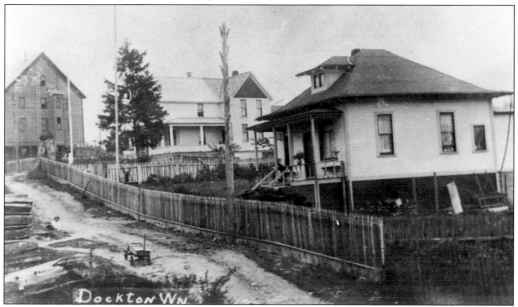

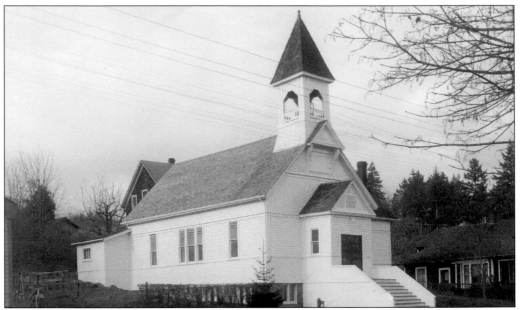

Although larger churches with island-wide congregations were moving into Vashon town as it expanded, smaller churches flourished, providing identity to local communities like Burton, Dockton, Colvos, Cove, and Portage. Burton Baptist Church (pictured around 1920) was organized in 1893, and the building was constructed in 1897. In 1928, it was reorganized as the Burton Community Church and today continues to serve the community as a multidenominational church.

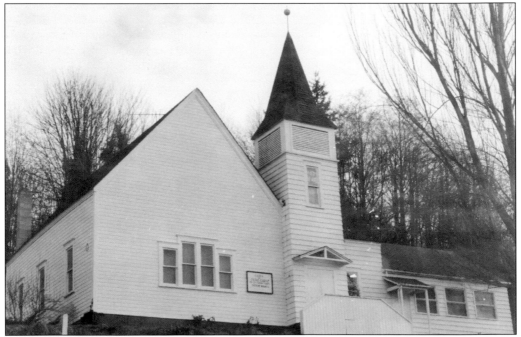

Cove Methodist Church (pictured in the 1970s) was established in 1905 with seven members. The building was dedicated in 1907 and served its congregation until 1956, when it merged with the Vashon Methodist Church. The building, which was used by the Church of Jesus Christ of Latter-day Saints from 1962 until its branch was opened in 1981, is now a private residence.

While many of the island's churches were already established, the Methodists built their new church (right) in 1907, and two years later the new Presbyterian church (below) was completed. In 1955, island author Betty MacDonald observed of these two in her book, *Onions in the Stew*, "A tiny white church up to its knees in nonecclesiastical currant bushes holds a bony arm bearing a small cross high up toward the pale sky. A large hipped white church glares disapprovingly at the movie theatre across the way." These two fine examples of early-20th-century church architecture still grace Vashon town and provide a reminder of the importance of organized religion on the island. In the early 1920s, the two churches briefly merged congregations, and although the governance proved problematic, that confederation prompts their cooperation to this day.

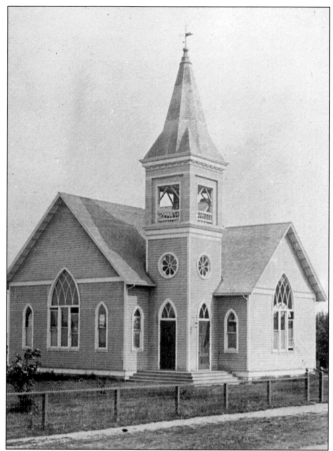

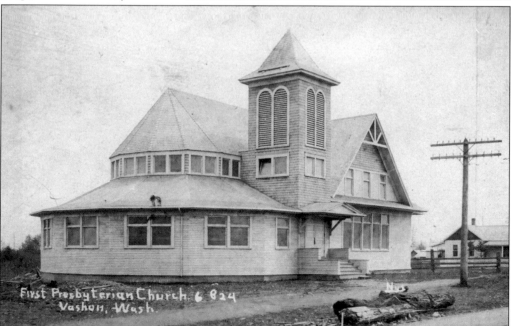

First Presbyterian Church 6 824 Vashon, Wash.

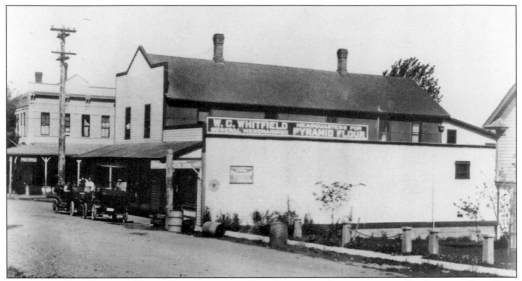

Burton emerged as the first important commercial center when, in 1892, the Petersen brothers opened the first exclusive meat market and the Miles Hatch building (above, left) opened with a general store run by William Clark and James Wylie. Today's Harbor Mercantile building (above, center) was built in 1907 as the Burton Trading Company. Originally Hammersmark Landing, Lisabeula's first post office opened in 1892, and its first general store opened in 1902, built by Anton and Maurice Baunsgard. In 1912, Anton built a large, two-story building on the waterfront (below, with the *Virginia II* at the dock) to house the general store, post office, and a feed store. Nels Christensen, owner of the *Virginia* steamboats, married the Baunsgards' sister Margaret and bought adjacent land from Maurice in 1908.

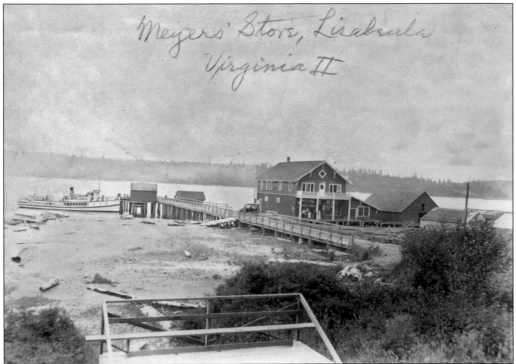

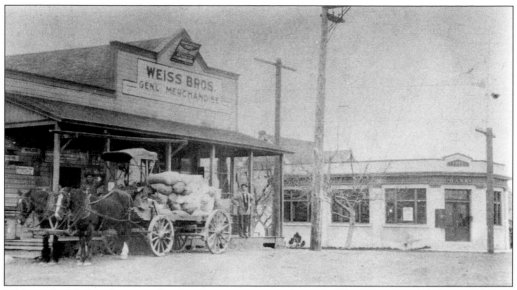

Ultimately, Vashon became the dominant commercial center. The Weiss brothers' general store (pictured in 1915) later became a hardware store and is now the Hardware Store Restaurant. Vashon State Bank, established in 1909, built a concrete and tile building at the main intersection (above, right) in 1912. A feed store, lumber store, YMCA, two-story brick Masonic hall, hotel, and the two largest churches on the island also anchored the town.

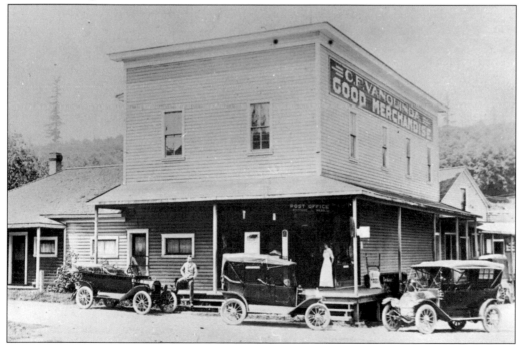

Portage, the link between Vashon and Maury, had a steamer dock and the first automobile ferry dock. Charles Van Olinda built Portage's first store in 1903, moving it north in 1906 to build the two-story structure (pictured) that remains today as a private residence. The island's first Rural Free Delivery originated here, and there was also Sherman's Portage House hotel (1910–1916), an Episcopal church, and the island's first automobile dealership.

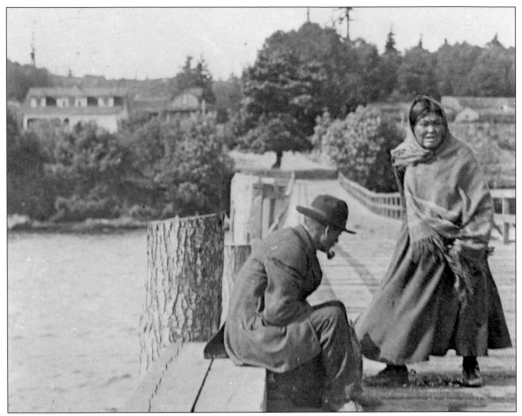

Documentation of the S'Homamish on the island is limited. Stories about Lucy Schoen's sewing and Tom and Lucy Gerand's clam digging abound. (Above is most likely a photograph of the Gerands on the Quartermaster dock.) Harlan Smith's archeological excavations in 1899, Thomas Waterman's Puget Sound Salish place name geography, the Earle O. Roberts artifact collection (now housed at the Burke Museum), Lynne Waynick's amateur collection (now housed at St. Martin's University), the Hands Across Time dig at Jensen Point, and native testimony are all that exist. Native people from other parts of the Pacific Northwest, many from the west coast of Vancouver Island (below, waiting for a ferry in 1919), began to come to the island in the 1890s as seasonal fruit pickers. They developed relationships with island growers and came annually for the harvest.

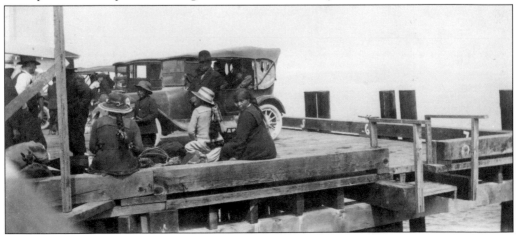

Four

TRANSFORMATIONS
1920–1945

The time between 1920 and 1945 consisted of transformations on Vashon-Maury Island. The dual depressions of the 1920s and 1930s forced the island to become a different community. The agricultural depression of the 1920s caused many to leave, and the population declined from 2,557 in 1920 to only 1,482 in 1930. With the Great Depression that followed, however, the population regrew, reaching 2,701 by 1940. This was primarily the result of the flood of migrants who moved to the coasts as the Dust Bowl crippled the center of the nation.

Economic collapse and technological changes led to major consolidations. When voters approved a new Union High School in 1929, the move to only one district began. As local post offices closed, Vashon-Maury shifted from 16 to ultimately only one. Shopping altered as local community stores closed; finally, only three shopping areas remained—those at Vashon, Center, and Burton. The 27 docks gradually diminished to two, while strikes and rate hikes constantly disrupted service. The predecessor of the community council was formed, giving Vashon-Maury its first political voice. Major roads connecting residents to the ferry docks were paved. The four primary economic engines of the island economy—logging, farming, mining, and fishing—all collapsed.

World War II saved the island and the rest of the nation economically. As young men joined the war effort and jobs flooded into the shipyards, aircraft factories, and other war industries of the region, Vashon-Maury benefited. An economic recovery took shape, and a newly refocused island emerged. However, World War II also saw the island's second internment (the first was the S'Homamish in 1855) when its ethnic Japanese residents were sent away to camps.

Two symbolic events marked this period of transformations: George McCormick's Round the Island Hike and the publication of Oliver Van Olinda's *History of Vashon-Maury Islands*. Both gave the island a view of itself as a single entity. Instead of seeing themselves as members of separate, isolated water-based neighborhoods, residents felt a sense of unification as an island community.

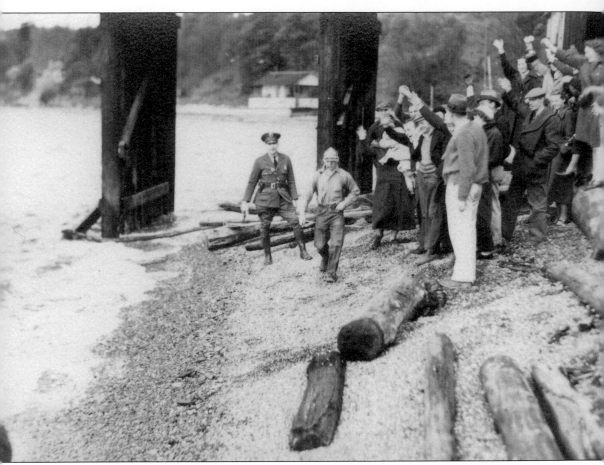

A defining event took place on Vashon-Maury Island just before World War II. In 1938, George McCormick, on a bet from a neighbor, agreed to walk around the 51-mile shoreline of the island in under 24 hours (above, at Tahlequah with Sheriff Finn Shattuck firing the starting pistol). Undaunted by high tides—sometimes wading up to his armpits—and without using path, road, or bulkhead, he completed the hike in 20 hours and 50 minutes. The event, while trivial on one level, united the island, as hundreds showed up along the beaches to cheer him on to success. A major shift of consciousness took place; this change did not occur with just one event, but through a series of small, incremental changes punctuated by numerous major shifts. The McCormick Round the Island Hike was emblematic of the shifts taking place during the 1920s and 1930s.

Oliver Scott Van Olinda came to Vashon in 1891 and wrote of his first walk from Langill Landing to Center, "I came from the great prairies of Nebraska and, as I walked . . . in the gathering dusk . . . giant fir trees towering three hundred feet above me on either side of the trail in an almost impenetrable wall and flanked by great banks of ferns, the beauty of the scene was overshadowed by the thought that such environment simply must harbor hordes of bears and catamounts. I marveled at the folly of man, in thinking he could ever convert such material into a farm, a garden, or even a home." In 1892 and 1893, he edited *Island Home*, a monthly magazine and the first publication on Vashon-Maury. From 1895 to 1897, he edited the *Vashon Island Press*, the island's first newspaper. He taught at Vashon College, served as historian for the Vashon-Maury Pioneer Society, photographed island events, and in 1935, published his book, *History of Vashon-Maury Islands*, adding one more step toward islanders seeing themselves as a unified island community.

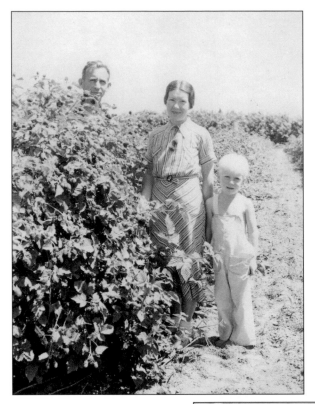

Vashon-Maury built much of its early success on agriculture, and when the national agricultural depression of the 1920s swept through, it took about 40 percent of the island's population. These were hard times, yet certain agricultural sectors prospered. Farmers turned to eggs, for instance, and by 1923 there were 150,000 laying hens on the island. Peter Erickson developed the Olympic blackberry, and in 1937, his son-in-law Hallack Greider (left, with wife, Pauline, and son Hal) formed the Olympic Berry Company, and the products were marketed by Frederick and Nelson department store. The first winery was Harley Hake's (below, his label). It was established in 1936 near Dockton, where Hake Road and the Old Winery Blueberry Farm are today. Hake made wines from grapes, berries, and flowers. Currently, there are three commercial vintners on the island: Andrew Will, Palouse, and Vashon Wineries.

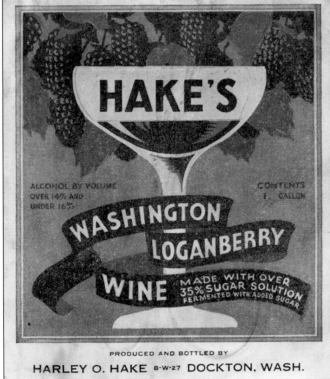

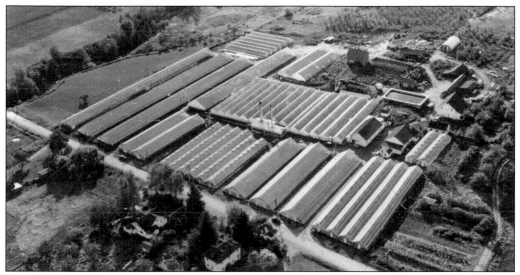

The Beall greenhouses (above, around 1940) became a mature business during the interwar years and began to shift emphasis from the garden farm vegetables that grew the business initially toward flowers—particularly orchids, roses, and a few other cut flowers. Ferguson "Fergie" Beall was fascinated with orchids and developed them while his brother Tom focused on roses. They shared the daily management of the operation. Below, orchids are being unloaded from Great Britain for preservation at Beall's during World War II. As the business developed, it became the largest employer on the island until it began to close operations in the 1960s. In 1923, Beall switched from coal to oil for heating and constructed a dock at Ellisport to import oil for its boilers. The pilings of the oil dock are still visible as one enters Ellisport from the south.

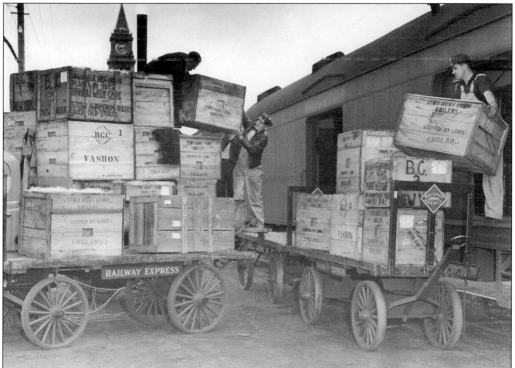

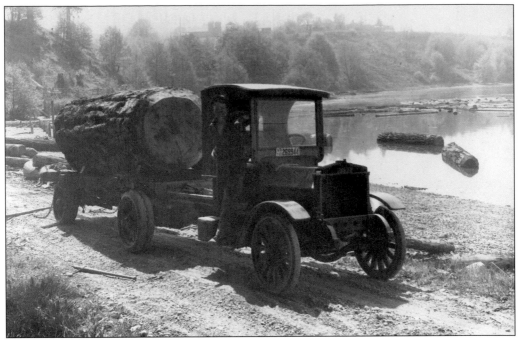

Between 1920 and 1950, logging on the island declined, and the remnant old-growth forests were almost totally eliminated. This is signified by the log being delivered to the Steen Mill (above, Ellisport, 1923). Where forests were cut, fires threatened. Major fires burned on the south end in 1922, in Paradise Valley in 1933, and at three other locations in 1939.

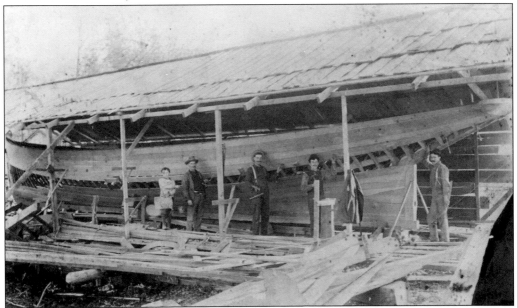

The shipyards at Dockton prospered until the 1930s. The Norwegian government ordered three ships, but cancellation of the contract at the end of World War I precipitated strikes. Later ships included the steamer *Vashona* in 1921 for the Quartermaster-Tacoma run, a ferry for Whidbey Island in 1923, and in 1929, the last large commercial boat was built at Dockton: the purse seiner *Janet G.* Above, Martinolich shipyard workers pose in thriving times.

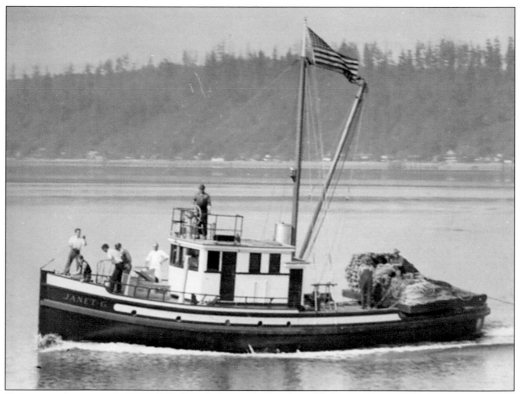

Fishing in the interwar period declined in Puget Sound, and fishermen traveled north to southeast Alaska following the diminishing salmon runs. The *Janet G* (above), launched in 1929, fished around Vashon as well as other parts of Puget Sound. In the 1930s, Joe Green Sr. began taking the *Janet G* to Alaska. His sons Joe Jr. and Skip continued to fish with the *Janet G* until 1996, when they retired and sold the vessel. Trips north and back and fishing in Alaskan waters were always dangerous. In 1934, the fishing boat *Umatilla* of Dockton (below, with crew), under the command of Capt. Lucas Plancich, wrecked after it was run down by the battleship USS *Arizona* off Neah Bay. Two crew members, Lauritz Halsan and John Urosac, were killed. (Below, Richard E. Warren.)

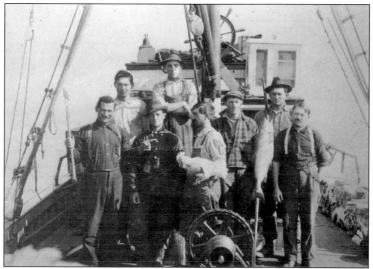

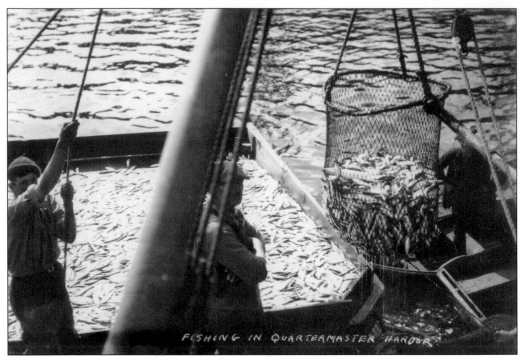

Fishing in Puget Sound continued to be productive for many years (as shown by this Norman Edson photograph taken in Quartermaster Harbor), even after the fish runs peaked in 1914 and began to decline. Successful fishermen worked all the various runs, including salmon, herring, cod, and other bottom fish.

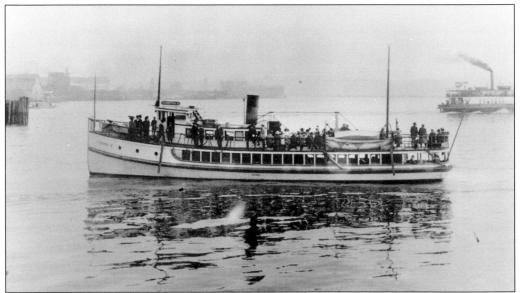

Past meets future in this Joe Williamson photograph of the passenger steamer *Virginia II*, with the *West Seattle* car ferry lurking in the background in Elliott Bay around 1912. In 1916, the first automobile ferry to Vashon-Maury made its premiere run. In the 1920s, the island had its best marine transportation system. Mosquito fleet boats still operated, and there were car ferry docks at Portage, Vashon Heights, and Tahlequah. (Puget Sound Maritime Historical Society, 4330.)

The north end dock (above, around 1931) emerged as the primary ferry landing after service began in 1919. When the Portage–Des Moines route was abandoned in 1921 and Fauntleroy dock in West Seattle opened in 1925, the pattern was set for the future of Vashon service to Seattle. Polled in 1939, islanders preferred service to Fauntleroy rather than the downtown dock, which saved Vashon-Maury from becoming just another bedroom suburb. The complicated mix of private and county services led to conflicts, and frequent strikes by ferry workers prompted calls for a state ferry system. As the Black Ball Line gained a monopoly, tensions increased. During the 1939 strike, islanders captured the ferry *Elwha* and held it at the dock so islanders would have a ferry if needed. Below, Elmer Harmeling serves stew to citizens at the sit-in.

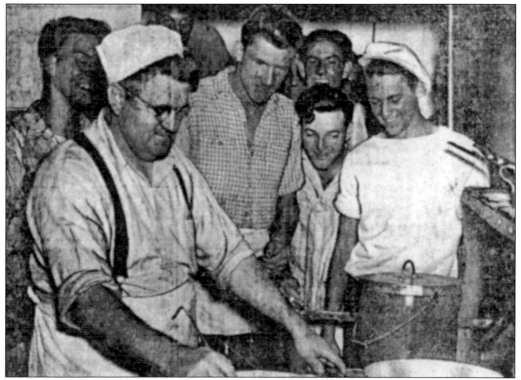

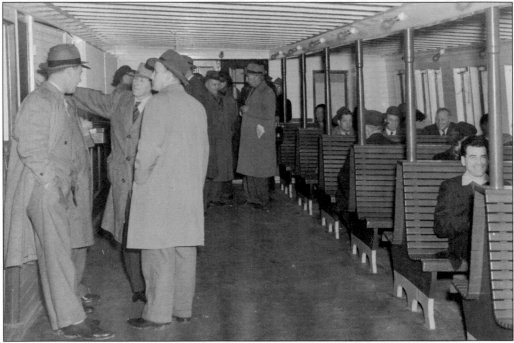

The mosquito fleet was dying under pressure from automobile ferries, but new boats were built to serve Vashon-Maury, including the *Vashona* (1921), *Virginia V* (1922), and *Concordia* (1931)—which ran the last steamer route, between Tacoma and Quartermaster Harbor—until 1940. Car ferries also attracted walk-on commuters, such as these passengers on the *Chetzmoka* in 1942. Other north end ferries included the *Vashon*, *San Mateo*, *Elwha*, and *Washington*.

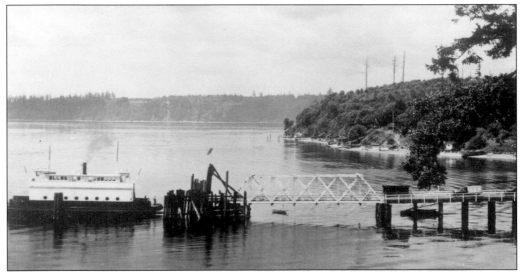

South end ferry service began in May 1920, and the Tacoma Chamber of Commerce sponsored a contest to name that landing. Ethel Whitfield of Burton won with Tahlequah (meaning "water view"), which is the name of a city in Oklahoma. The *Fox Island* (above, 1942) was one of the ferries serving this route. When the Narrows Bridge collapsed in 1940, Tahlequah service was reduced so that its ferry could also run the Gig Harbor–Point Defiance route for those who would normally use the bridge. (Robin Paterson.)

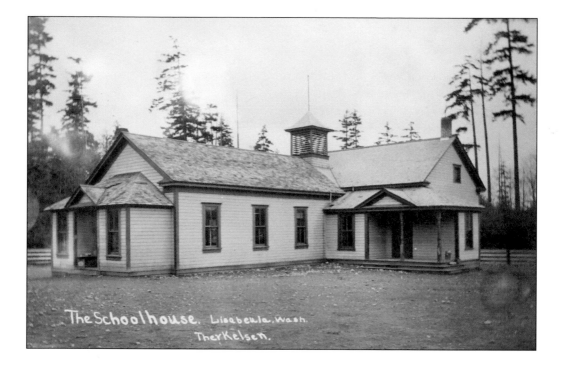

The Schoolhouse, Lisabeula, Wash.
TherKelsen.

The story of Vashon-Maury schools ends in consolidation. In 1920, there were eight school districts with buildings such as the Lisabeula School (above). But in 1941, the island voted to form a single district. Consolidation began when the southern Vashon and Maury districts joined to form Burton High School in 1913. There were two rival high schools, Burton and Vashon, until 1928, when the island voted to form a Union High School district and selected a 20-acre site along the main highway at Center. In 1929, a bond issue to build the new school (below) was passed, and in September 1930, it was dedicated. However, the first Union High School graduation took place in June 1930 in the old facility with 37 graduates—the largest number at that time ever to graduate from high school on the island.

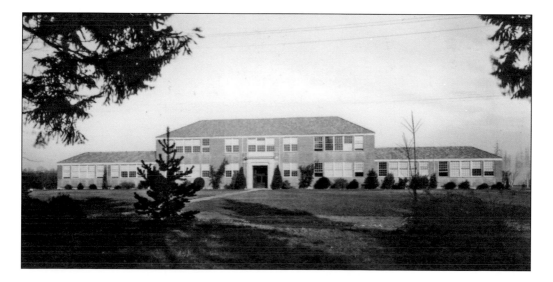

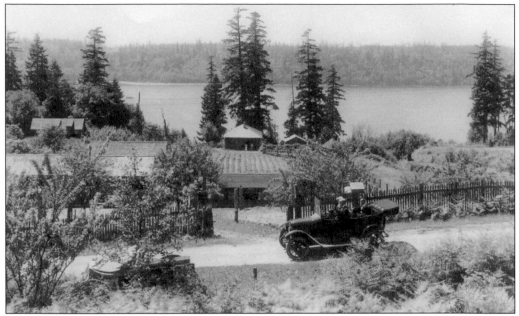

The introduction of the automobile was one of the primary forces shifting Vashon away from a collection of isolated water-based communities and toward a self-identified island community. As more people settled on the island, the road network grew. This dirt road (above, at Cove, showing the Renouf farm) later became Westside Highway. The highway from the north end to Center (below) was paved with concrete by Henry J. Kaiser's company in 1920. The $185,000 cost was split equally between the state and property owners. The road to Dockton opened in 1925, and the Burton-Shawnee Road was extended to Tahlequah in 1932. By the end of World War II, the present road network was largely in place, although many roads would not be paved until the 1950s and 1960s.

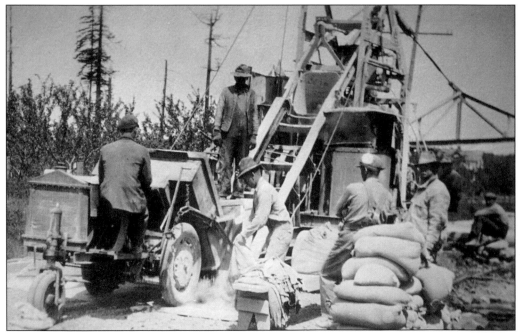

The automobile changed daily life on the island forever. A good example of its impact is Dr. Frederick McMurray (right, with his Model T). McMurray, for whom the middle school is named, was Vashon's only doctor. The automobile allowed him to make house calls at any time, and he delivered more than 600 island babies—most of them at home. He was a true country doctor. Although the mobility offered by cars caused the demise of local community stores and post offices, the servicing of cars became a major business, sparking the appearance of numerous gas stations, several car dealerships, and the construction of parking lots such as the one at the north end dock. In the photograph below, three-year-old Bob Smith sits on the spare tire of his parents' Model T.

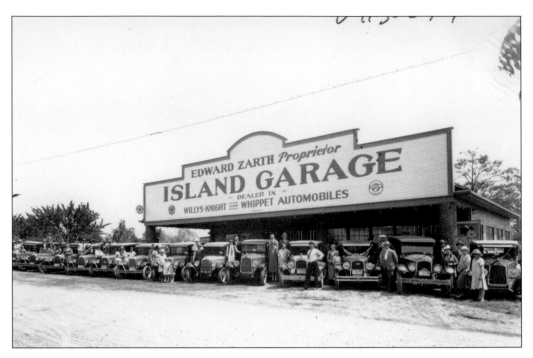

As cars flooded onto the island during the 1920s, road construction flourished. At one time, there were at least three automobile dealerships—Ford, General Motors, and Zarth's Willys-Knight and Whippet Island Garage on the site of the old Baptist church (above, at Center, around 1928). More than half a dozen gas stations and additional gas pumps at every community store made it easier for car owners to move around the island. Also, as roads grew, ferry service expanded, buses from Seattle and Tacoma instituted island routes, and jitney (unlicensed taxi) services developed (below). Easier travel began to break down the isolation of the many water-based communities that had been dependent on the mosquito fleet as their major form of transportation.

Roosevelt, Martin, Taylor Swept Into Office As Island Voters Turn Out In Numbers

Despite cold, raw weather Island voters on Tuesday turned out in large numbers, and in several precincts a 100 per cent vote was cast.

Already reeling from the effects of severe agricultural depression, the 1929 economic collapse hit the island hard, and the Great Depression only made conditions worse. For the first time, Vashon-Maury opted for a Democratic president, voting for Franklin Roosevelt in 1932 by a margin of 704 to 534 and again, in 1936 (above), by a margin of 751 to 510. Residents also voted for Democrats Clarence Martin as governor and Jack Taylor as county commissioner. This was the beginning of the island's shift away from a solid Republican electorate to becoming a stronghold of liberal Democratic politics. The Goodwill Farm (below) became a place for indigents to work and live. As the Depression deepened, teachers on the island had their pay reduced by 20 percent, and meetings were held to break away from King County and form a separate county.

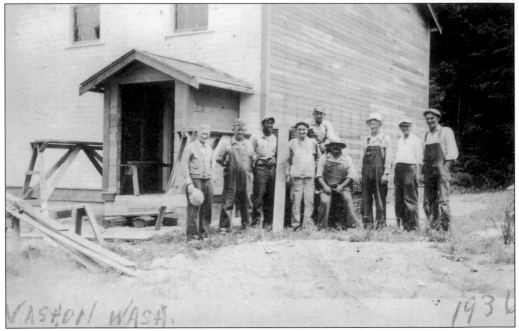

VASHON WASH. 1936

The impact of the Great Depression was mitigated by Roosevelt's Public Works Administration (PWA) and Works Progress Administration (WPA). Earning 45¢ per hour, 10 workers cleaned the Vashon Cemetery in 1933. In 1935, Vashon received $11,000 to construct a road barn, road service buildings, and a jail at Center, which the King County commissioners had promised to build in 1930. In 1936, a new gymnasium (above) was built for Columbia School, and sidewalks were built at Vashon and Dockton. In 1936, Vashon-Maury Park was created at Dockton, and WPA workers constructed its seawall and bathhouse (below). As late as 1939, thirty-eight men were employed to survey the island and establish clear section lines, and a crew worked at Point Robinson constructing the road down the hill and filling in the meadow with the debris.

VHS. 044

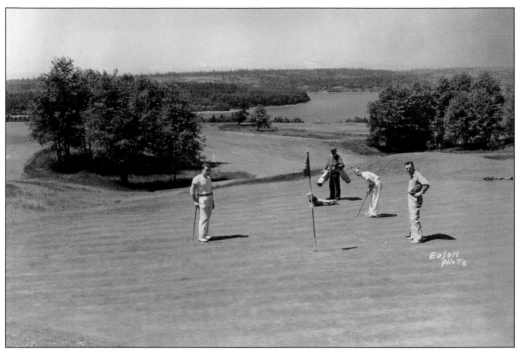

Vashon-Maury has always had an active group of clubs and organizations that filled the important functions of social contact and community leadership. In 1929, the Vashon Golf and Country Club (above) opened its golf course on Maury Island, where it still occupies its original location. The club purchased land from the old Melita Farm of Miles Hatch, designed and constructed a nine-hole golf course, and hired a golf professional to manage it. In 1933, the Vashon Rod and Gun Club, later renamed the Sportsmen's Club (below, 1946), was formed. Like many of the first environmental organizations in the United States, its goal was to preserve fish and game so that sportsmen could continue to hunt and fish. Its first major activity was sponsoring a drive to destroy feral cats in order to protect poultry and native birds from predation.

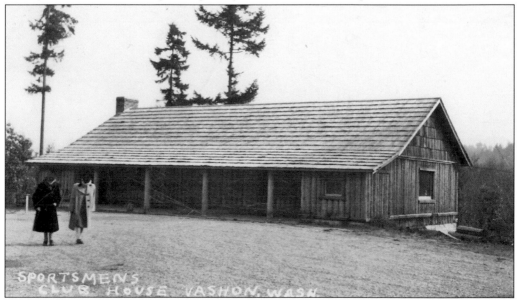

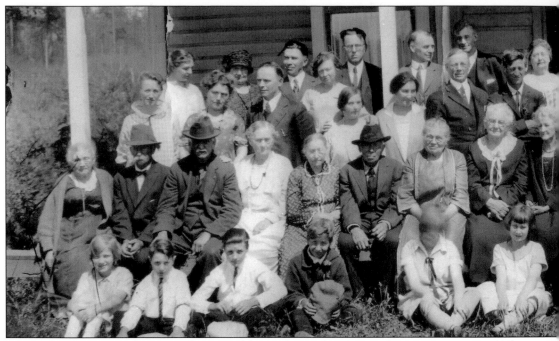

The Vashon Pioneer and Historical Society (changed to Vashon-Maury Pioneer Society in 1929) was organized in 1923. The surviving pioneer families gathered in front of the Odd Fellows hall (above, now Vashon Allied Arts) for a 1925 picnic. Its first project was to erect a monument to Vashon pioneers, which was installed at the foot of Monument Road and dedicated in 1927. The Vashon Island Women's Club began in Burton in 1911. Members exchanged magazines by leaving them in a stump covered with a shingle. In 1914, the group incorporated and started the first lending library—charging a penny a day for a book—which operated until the county took over in 1944. Members also met socially, as seen below in 1917 (page 68), where they are dressed in costumes to

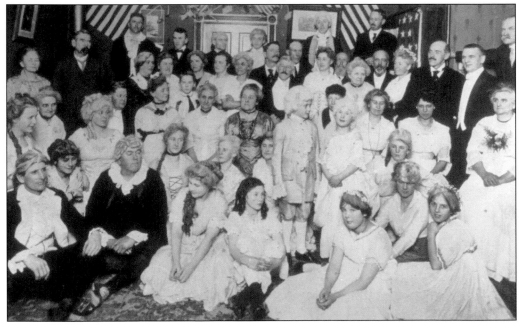

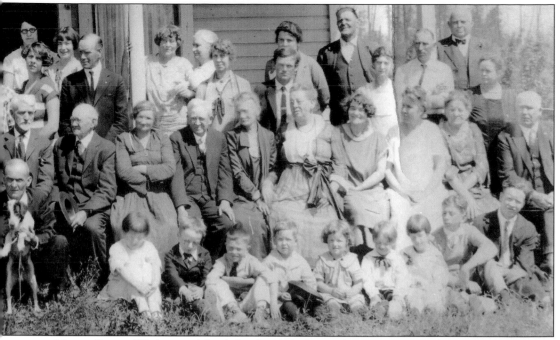

celebrate George Washington's birthday. In 1925, the Mark P. Waterman Lodge No. 177 of the Free and Accepted Masons bought the Burton Woodmen of the World building, erected in 1884, for their lodge. It continues to serve that purpose today, as well as being home to the Silverwood Gallery. The first Democratic Club, founded in 1933, organized in response to Roosevelt's election. The abandoned Vashon School, located at what is now Ober Park, was purchased by Vashon Community Club and turned into the Island Club, a meeting place and entertainment hall. Other clubs included the Odd Fellows, Camulos Club, Daughters of the American Revolution, and the American Legion. Pictured below (page 69) are the Knights Templar in front of the Presbyterian church in 1938.

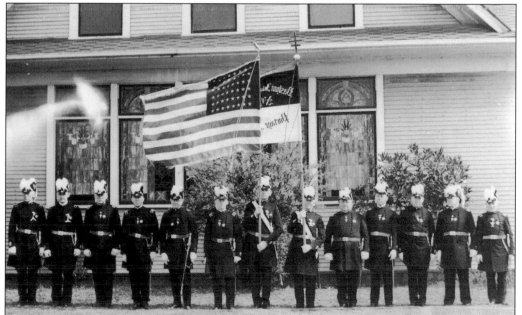

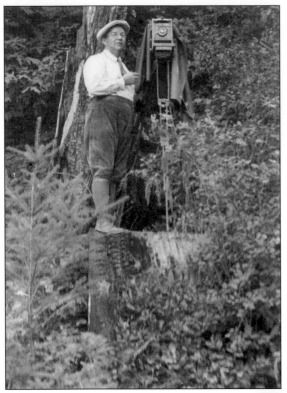

Norman Edson (left) was born in Quebec in 1876. He came to Vashon-Maury in 1921 after studying painting in Paris and working as a photographer in Quebec and Everett. He photographed many Vashon-Maury scenes and activities and developed his skills at gold-tone and hand-tinted photographs. He is perhaps best known for his photograph of Mount Rainier titled *Sun's Last Glow*, pictured below. It was taken from the north end of Vashon in the 1920s. That photograph was the one, Edson said, that paid the mortgage and was produced in sizes from greeting cards to five-foot colored enlargements. Edson's home and studio, with a view of Quartermaster Harbor, was located in Burton next to the Burton Church. He was also a painter, poet, writer, and radio personality. He died in 1968.

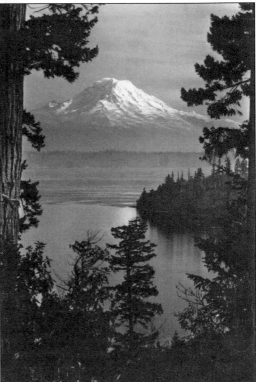

Early on, Vashon-Maury became a site for summer escapes. The Chautauqua assembly at Ellisport began a pattern of resorts and summer camps that still exists today. Opened in 1922, Camp Sealth (pictured with Camp Fire Girls on the beach) is the largest and longest-operating camp on the island. Named after Chief Sealth, for whom Seattle was also named, the facility has grown to its current 500 acres.

The Vashon Theatre began as a YMCA that was built in 1904, but it was sold and converted to a silent movie house in the early 1920s. When it burned in 1945, a temporary theater operated in the Island Club until a new building, the current Vashon Theatre (built across the street from the original theater) opened in 1947.

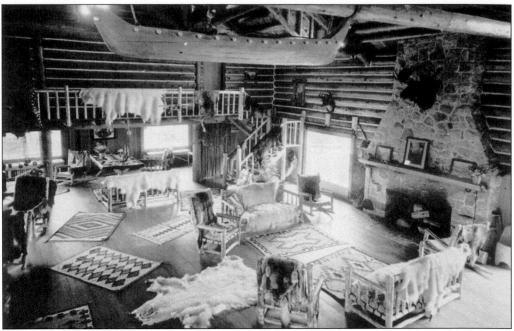

While the dual depressions of the 1920s and 1930s affected many on the island, others still had the resources to come to Vashon-Maury for summer leisure and escape. Some built large ornate houses that were used as second homes or summer retreats. Falcon's Nest (above, near the north end), with its dugout canoe used as a lighting fixture, was characteristic. Others continued to patronize the lodges and summer camps scattered around the island. Swastika Lodge near Glen Acres, Luana Beach Resort, Portage Hotel, Manzanita, Marjesira Inn at Magnolia, Camp Sealth, Camp Burton, the Lisabeula resort, Cove Motel, Madrone Inn at Ellisport, Spring Beach resort (below, with Tacoma visitors by the fountain), and others provided an escape to those who could afford a vacation away from the city.

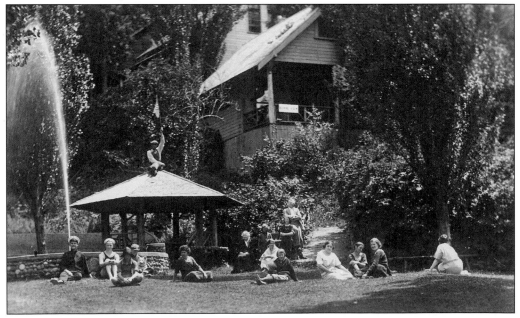

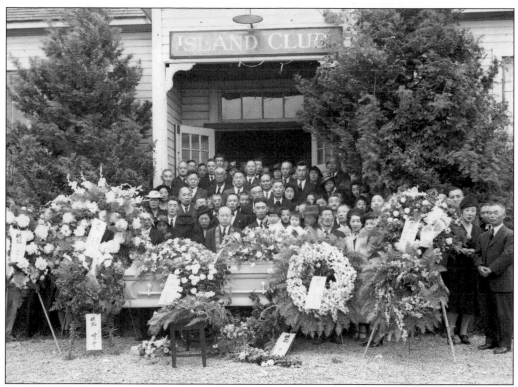

The first Japanese came to the island in the 1890s and quickly established successful farms. American immigration policy limited Japanese immigration with the Gentleman's Agreement in 1907 and excluded anyone of Mongolian descent in 1924. The 1921 Washington-Japanese Land Act prohibited Japanese ownership of land. Both the funeral of Kengo Yorioka in 1938 at the Island Club (above) and Mukai Gardens (below)—which were considered unique because they were designed by a woman, Kuni Mukai—are representative of Japanese American life on the island. The Japanese community formed the Vashon Island Progressive Citizens League in 1930, and in 1931, it donated 100 cherry trees to the new Union High School campus. In 1942, just before internment, the Japanese American Club published "The Creed of the Japanese American," which pledged loyalty to the United States.

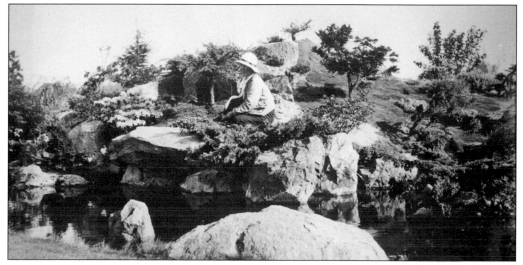

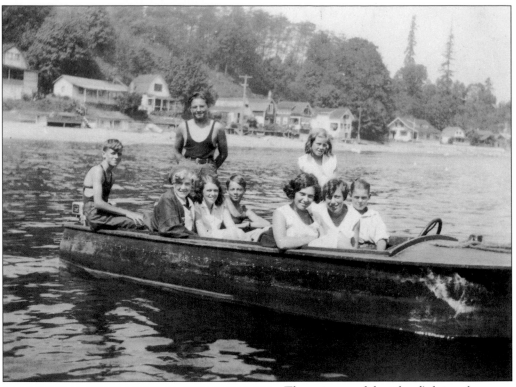

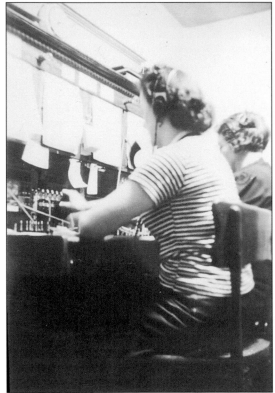

The epitome of the island's leisurely lifestyle is captured in the photograph above (early 1930s) of an outboard speedboat loaded with teenagers—including island author Bob Gordon (far left)—at Magnolia Beach. Everyday life also saw many utility improvements. A submarine cable brought power to the island in 1921, and the old steam-generating plant closed. Puget Sound Power and Light began supplying electricity to the island in 1922, and by the end of the decade, most communities were hooked up. Telephones arrived, as seen in the photograph at left. In 1924, three operators provided service, but not from 10 p.m. to 8 a.m. This continued until 1925, when 24-hour telephone service began. By 1927, there were six operators and 600 subscribers. Westside Water formed in 1928, and Island Mutual Water began operating in 1929 at Portage. Ellisport's water system, established in 1940, eventually combined with Vashon District 19.

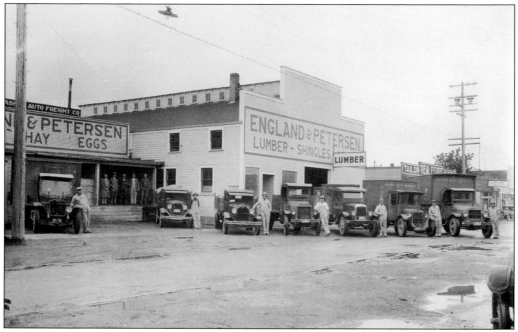

Though the businesses that originally flourished were largely those that supported agriculture, England & Petersen (above, around 1930) dealt in lumber as well as feed. Vashon Auto Freight headquarters got its start in a shed in the back. With Vashon-Maury's central location in Puget Sound, it quickly became the location of choice for radio stations broadcasting in Seattle and Tacoma. The line-of-sight broadcast signal of AM radio gave towers on the island the ability to reach virtually everywhere in the area. KVI built the first radio tower on Vashon at Ellisport in 1936. KIRO, with 15 employees, built its tower and broadcast facility (below) on Maury in 1940. By 1948, there were more than 50 radio employees on the island, and they formed the Ki-Mo-Vi-Ro Radio Engineers and Wives Club, named after the four radio stations: KING, KOMO, KVI, and KIRO.

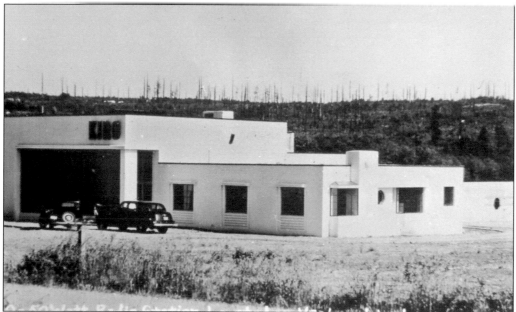

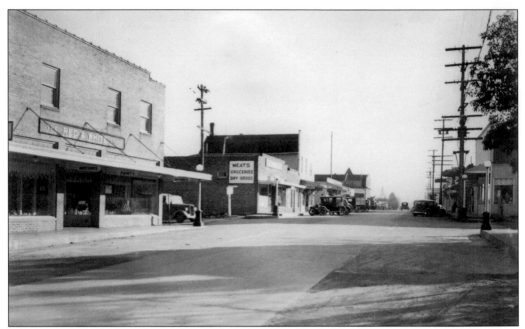

These views of Vashon looking south (above, 1920) and north (below, 1932) show the retail center. Automobiles and roads made getting to this town much easier, signaling less dependence on the community stores. In 1926, the last large fir stump was removed from the town, and in 1930, the main street was paved. The side streets were not paved until the 1950s. Vashon town formed water district 19 in 1926 and installed rams at Vashon Landing to lift the water to the town water tower. In 1933, these rams were replaced with electric pumps. Fear of higher taxes and higher utility costs, however, led islanders to vote against creating a King County Public Utility District in 1938. A similar proposal was defeated in 2008. (Below, University of Washington Libraries, Special Collections, UW19165.)

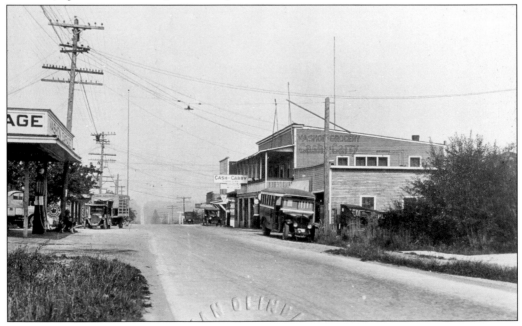

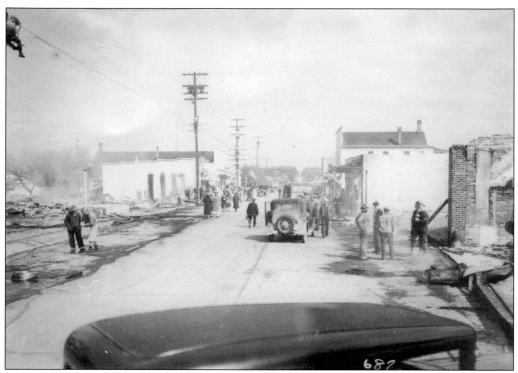

The S'Homamish used fire to clear land for pastures and to encourage crops of native plants. Forest fires swept through regularly when logging was at its peak. Some fires were massive, burned for months, and denuded large swaths of the island. Fires also affected the towns on Vashon. The Dockton Hotel burned around 1915. In Burton, three buildings were lost in 1920. In 1933, much of Vashon burned, destroying the downtown core (above). A volunteer fire department formed at Vashon in 1926, and the only fire truck on the island was lost in the 1933 fire. This led to a number of attempts to form a fire district, and in 1942, a King County Fire Protection District (below, campaigning) became the basis of the current Vashon Fire and Rescue.

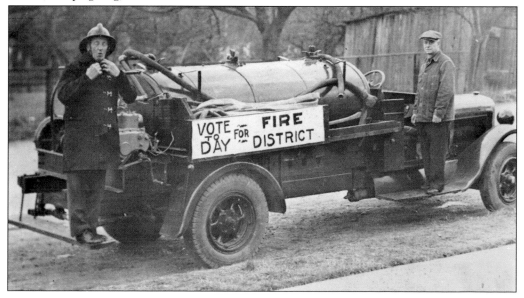

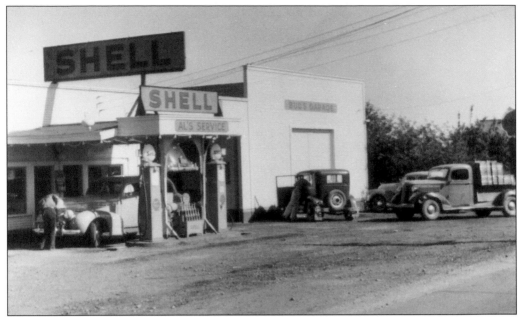

Several important island businesses that were started during this period remained familiar island institutions through the post–World War II years. Augustus Bacchus founded Bacchus Lumber in 1926, and George McCormick launched Vashon Hardware Company in 1929. As the automobile came to dominate island transportation, numerous garages and gas stations opened, including Al's Service and Bud's Garage (above). Island businesses supported the recovery efforts of President Roosevelt's New Deal by pledging to support the National Recovery Administration. When Prohibition was repealed in 1933, the island voted 403 to 313 to be "wet," and the first bar on the island, the Beach Tavern (below), opened at the foot of the north end ferry dock.

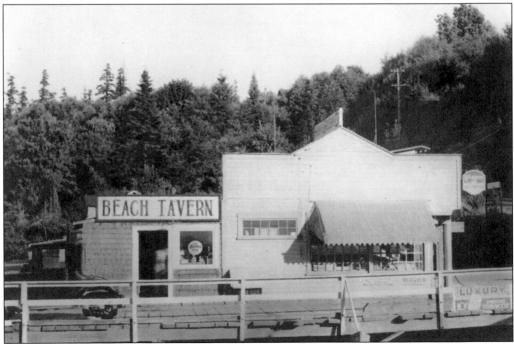

By 1920, the S'Homamish were mostly gone from the island, although a few individuals and families continued to live and work there. In 1927, a land claims tribunal heard testimony from Lucy Gerand (right, center), a S'Homamish elder, about villages on the island. Gerand (1836–1929) was buried in Vashon Cemetery, but her grave remained unmarked until 2008, when a monument was finally erected. Native people from other areas and tribal groups came to Vashon-Maury as laborers, such as these British Columbia First People pictured below in a north end strawberry field in 1943. This began a pattern in which most native residents were not S'Homamish. Today, there are no S'Homamish on the island, and the Native Americans are from other tribal groups. (Right, © the *News Tribune* [Tacoma, Washington] 1927, reprinted with permission, and Tacoma Public Library; below, Museum of History and Industry, *Seattle Post-Intelligencer* Collection, PI23856.)

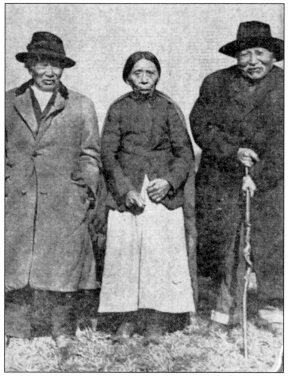

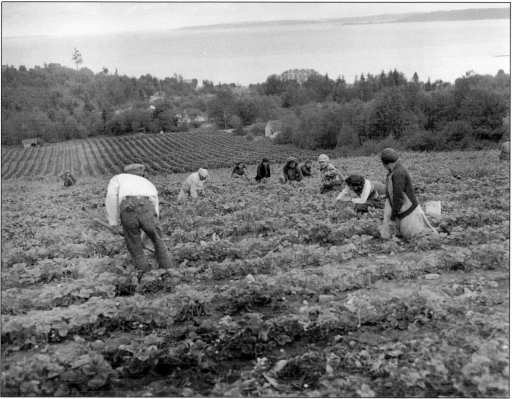

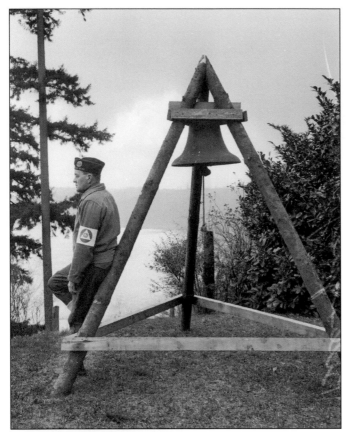

World War II began for the United States with the bombing of Pearl Harbor on December 7, 1941, and the island quickly responded. Paul Billingsley (left, with a Vashon warning bell) was appointed commissioner of island civil defense, air raid observation posts were set up, air raid drills were held, and blackout regulations were enforced. Island residents responded with scrap iron, copper, paper, and rubber drives to help the war effort (below). Fuel, tires, coffee, shoes, meat, and many other items were rationed, and the Office of Price Administration set the cost on most items. The island continued to support Pres. Franklin Roosevelt by helping elect him to his fourth term in 1944. (Left, Museum of History and Industry, *Seattle Post-Intelligencer* Collection, PI27993.)

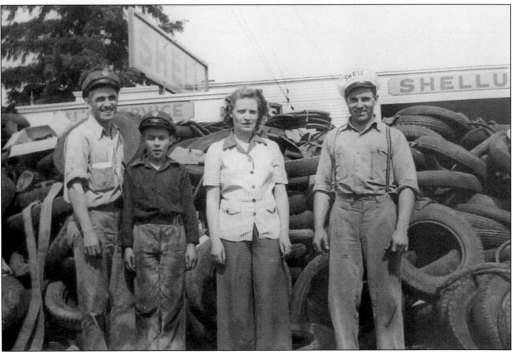

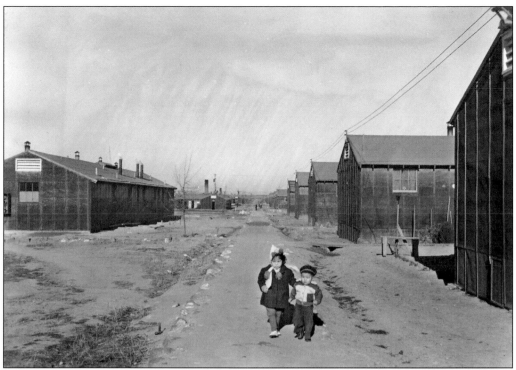

During World War II, all Japanese along the Pacific Coast were interned. In February 1942, the United States transported 126 island Japanese to Camp Harmony in Puyallup. From there, they were sent to any number of bleak inland camps, such as Minidoka in Idaho (above, where two children walk between barracks), or Heart Mountain, Wyoming (right, the island's Tsuto Otsuka family). In December 1941, the *Vashon Island News-Record* called for balance in dealing with the Japanese. But as the war progressed, a 1943 editorial urged, "Leave the Japs Where They Are," and in 1945, the paper supported Gov. Monrad Wallgren's opposition to allowing Japanese to return. While many islanders supported their friends and neighbors, others did not. (Above, Wing Luke Museum.)

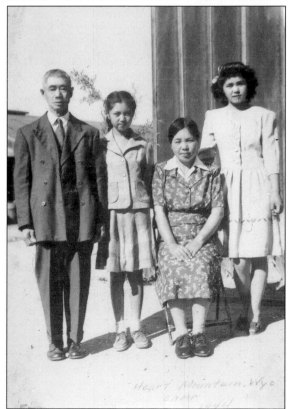

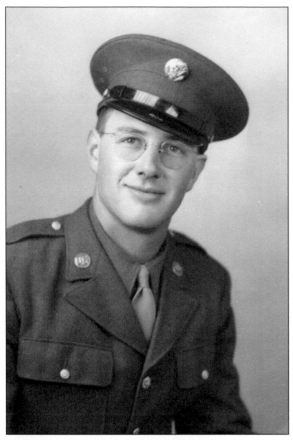

During World War II, more than 400 Vashon men and women served with distinction and honor. Two representative stories are those of Roy Bailey (left) and Augie Takatsuka (below, far left). Bailey was drafted in 1943 and served in Europe with the 3rd Armored "Spearhead" Division as a mechanic. He fought in the Battle of the Bulge and returned to Vashon to be a postman but suffered from bad dreams for several years. Takatsuka was interned at Tule Lake and then at Minidoka, where he joined the all-Japanese 442nd Regimental Combat Team, the most highly decorated unit in American history. In 1943, he was sent to Italy, and he fought there until his unit was sent to southern France, where he served until the war ended. Takatsuka returned to Vashon, purchased land, and began farming. He, too, suffered from horrible nightmares.

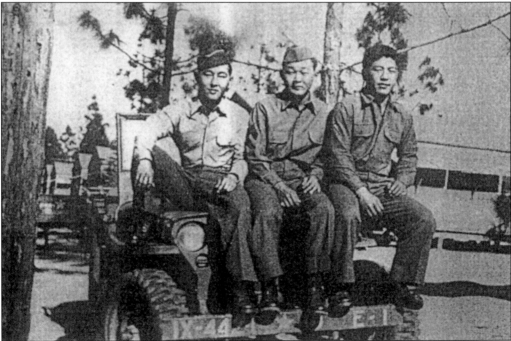

Many island families lost sons in the war. The Bacchus family sent four sons, but as the war neared its end, only two returned. Thomas (right), a lieutenant, was flying Hellcat fighter planes in the Philippines when he was shot down in November 1944. He saluted farewell to his wing mate as his "plane plunged in a tailspin to the ground." Only two months later, Douglas "Ladd" (below), a second lieutenant in training in Louisiana as a bombardier, got a ride home for leave and died when his plane crashed in the Oregon mountains. Donald, an Army sergeant fighting in Italy, was then returned to the United States. The youngest son, Sydney, who had just joined the Navy, was reassigned to Sand Point Naval Air Station in Seattle to complete his training.

ISLAND ROLL OF HONOR
WORLD WAR II

AGREN, HAROLD BACCHUS, DOUGLAS BACCHUS, THOMAS HERMANSEN, HANS HOFLIN, RUSSELL INGRAHAM, JOHN

MARSHALL, ROBERT McKINSTRY, JOHN McQUADE, ROBERT MILLER, JOHN MOE, EINAR NELSON, OSCAR SHUMWAY, ROBERT P.

Vashon postmaster John Ober began the compilation of the Island Roll of Honor in 1943 to pay tribute to the island's military men and women. A gold star was placed next to the names of the 13 lost: Harold Agren, Douglas Bacchus, Thomas Bacchus, Hans Hermansen, Russell Hoflin, John Ingraham, Robert Marshall, John McKinstry, Robert McQuade, John Miller, Einar Moe, Oscar Nelson, and Robert Shumway. There were Vashon veterans serving in every branch of the armed services and in every theater of the war. Of the 431 men and women recorded, many members of the same families served. Each community sent off its young to become what would later be called "the greatest generation." There are 20 women among the names, and 12 of the veterans were Japanese Americans who had been interned before they volunteered and were sent to the European front. The framed Island Roll of Honor originally hung in the Veterans of Foreign Wars hall. It is now on display in the Vashon-Maury Island Heritage Museum.

Five

POSTWAR GROWTH
1945–1980

During the postwar era, Vashon-Maury developed into what scholar Benedict Anderson terms an "imagined community," defined as "a conception of collective existence and sovereignty that people have despite the fact that they will never all know each other." Islanders seeing themselves as a population distinct from others united a heterogeneous, often contentious collection of individuals around a vision of what they shared. The stage was set for modern Vashon-Maury, where people define themselves as islanders rather than residents of Cove, Dockton, or Tahlequah.

Postwar suburbanization, a commuter-based economy, and the baby boom all led to a very different island compared to that which existed in 1900. The population grew steadily from 2,701 in 1940 to 7,377 in 1980. These changes brought with them conflicts and tensions. Only a quarter of the island's Japanese returned from internment camps. Those who did return found a mixed reception. The island formed its own ferry district to provide reliable ferry service, which helped lead the way to the formation of the Washington State Ferry System. Most islanders enthusiastically welcomed the idea of a cross-sound bridge at Vashon Heights, but they were bitterly disappointed when the plans were cancelled in the early 1960s. The Cold War impacted Vashon when the US Army developed the Nike missile base at Sunrise Ridge. The baby boom forced the island to construct new grammar schools at Vashon and Burton and a new high school at Center. An emerging community of artists and writers found homes on Vashon and laid the foundation for the thriving arts scene that exists today. The hippies arrived, and Vashon became a haven for the counterculture of the late 1960s and early 1970s. The new arrivals were met with a variety of responses, from acceptance to outright hostility.

As change swept the island, a new class divide emerged that echoed the stratification of the original settlers. Islanders entrenched in the traditional service and resource economies confronted a new class of professionals and commuters who brought a different set of values to the community.

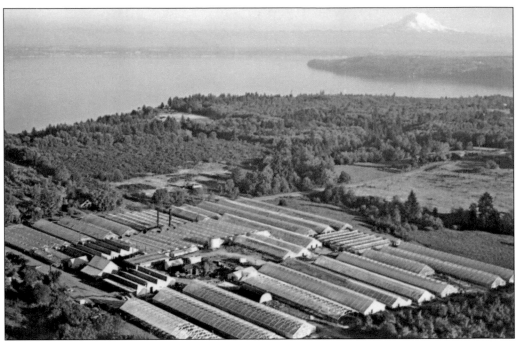

After the war, the big four extractive resource economies changed dramatically. Agriculture declined with the exception of very specialized crops like berries, greenhouse flowers, and orchard fruits. Labor laws changed the use of migrants and children as pickers, and by the late 1970s, "U-pick businesses" were the only berry farm survivors. The expanded Beall greenhouses (above) continued to grow roses and orchids, but increasing costs, environmental regulations, and better economic conditions in California and Colombia led to their eventual closure in favor of these other locations. Bob and Betsy Sestrap (below) were able to keep the Wax Orchards profitable by diversifying and developing a line of natural fruit juices that preserved their operation long past many of the other orchards on the island.

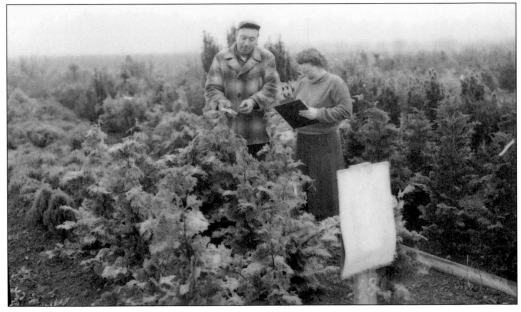

The Japanese Americans who returned excelled at farming, just as they had before, and in 1957, Yoneichi Matsuda was named Conservationist Farmer of the Year by the King County Soil Conservation District. Milton Mukai drove the Mukai family's Vashon Island Packing Company truck in the annual 1949 festival parade (above). However, the economic structure for agriculture changed in the 1970s, owing to concerns about the living conditions of migrant workers and laws requiring berry pickers to be at least 12 years of age. Profit was further diminished when Washington State applied minimum wage laws to pickers. The face of the berry picker was now that of a white teenager, such as those photographed below at the Otsuka farm in 1975.

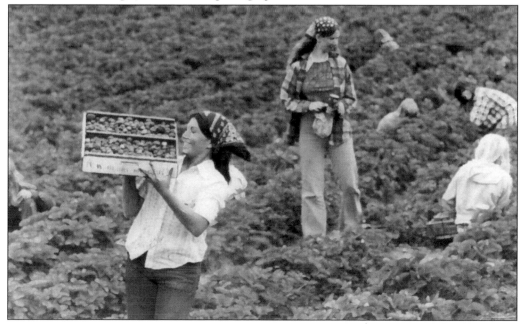

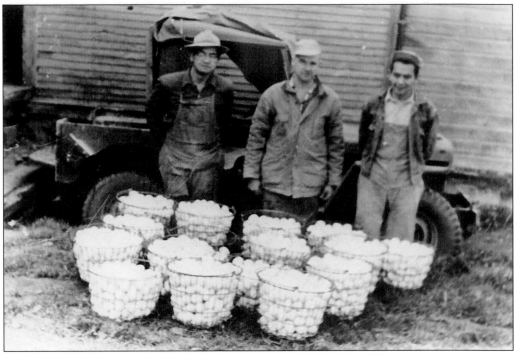

Specialized farming was the way to success after World War II. Eggs, fruit juices, jams, and preserves all had substantial markets. A devastating fire in 1946 destroyed the Vashon Island Cooperative Hatchery with a loss of 30,000 eggs, which gives some idea of the scale of operations. Started in the 1920s, Smith Poultry grew to 29 acres and 12,000 chickens before closing in 1985. Above, Bob Smith (center) is included in this photograph from 1960.

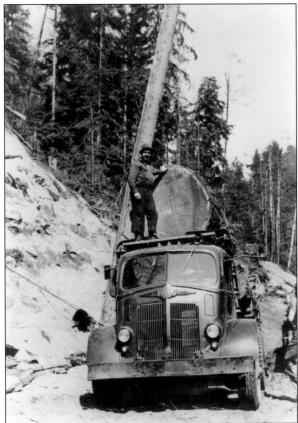

Logging, which had been the original economic engine of the island, died out in the 1950s. The last of Vashon's old-growth trees were cut in Cedarhurst, where Hank Olson (left, 1948) proudly displays one of the last big logs harvested. Afterward, logging as an occupation was much reduced, employed only to clear home sites and harvest second-growth fir, which remain its mainstays to this day.

As fishing declined in Puget Sound, the island fleet traveled north to southeast Alaska. Some fishing continued in the waters around the island, but the catches were reduced, as was the number of fishing days since governments instituted regulations to preserve what was left of seriously diminished runs. Three fishing boats, a vestige of the former fleet, are moored at Dockton in 1957.

Mining also was reduced significantly, as three of the four sites on the east side of Maury closed. The mine pictured became King County's undeveloped Maury Regional Marine Park, another became the Gold Beach housing development, the third was left unused, and the fourth, the current Glacier site, was mainly utilized for sand and gravel on Vashon-Maury with relatively little being shipped off the island.

The gravel pit at what would become Gold Beach was operated for many years during the 1920s by the Pembroke Investment Company. The demand for Vashon gravel and sand diminished as a result of competition from other mainland mines, and the pit was abandoned. Dom Spano and William Joslin, realizing the developing demand for housing and seeing an opportunity, bought the property. In 1967, they began to transform it into a housing development. First, they washed down the hillside with hydraulic hoses to level the land for building sites, then an access road was built down the hill. Once it was ready, lots in both upper and lower Gold Beach went on the market. In this photograph from October 1976, Gold Beach is seen from Pembroke Bluff. The remaining gravel mine on Maury Island, to the south of Gold Beach, became a center of controversy in the beginning of the 21st century when islanders organized opposition to a major expansion of the Glacier mine.

During World War II, the ferry strikes, rate hikes, and service disruptions that characterized the 1930s were put on hold, but after the war, ferry service again became chaotic. In early 1947, Black Ball Ferries announced a 30-percent fare increase. Islanders raised $1,500 to fight the increase and went en masse to Olympia to protest the hike and support the creation of a state ferry system. In 1948, King County Ferry District was created and elected commissioners who started service on March 1, 1948. Those chosen were, from left to right, George McCormick, Paul Billingsley, Charles Law, and George Walls. On Saturday, May 15, 1948, "Vashon vigilantes," some of whom were armed with clubs, sprang into action and prevented the Black Ball ferry *Illahee* from landing, keeping the vessel from competing with Vashon district ferries. The *Illahee* withdrew. Eventually, from 1948 to 1951, the district operated a three-boat service. Their success encouraged the state to get involved, and in 1951, the Washington State Ferry System was established, purchasing the Black Ball fleet and incorporating the Vashon ferry district.

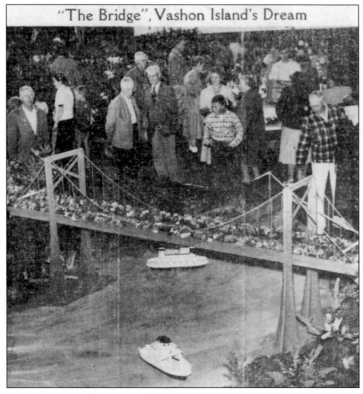

"The Bridge", Vashon Island's Dream

Ferries were considered to be temporary until a network of cross-sound bridges could be built. The Vashon Bridge was projected to bring a population of 50,000 to the island, and in 1950, its popularity was signaled when the Garden Club featured it as the centerpiece of its annual flower show (left). The bridge was approved but delayed several times. It was put on hold in 1961, never to be realized.

The island's relationship with the new state ferry system became troubled when a series of strikes by the Inland Boatmen's Union in the mid-1970s cut the island off from the mainland, with only one ferry for emergencies. When the strike was resolved, the state passed no-strike legislation for state employees—though there was one wildcat strike in 1981—and the ferry issues shifted to quality, frequency, and cost of service.

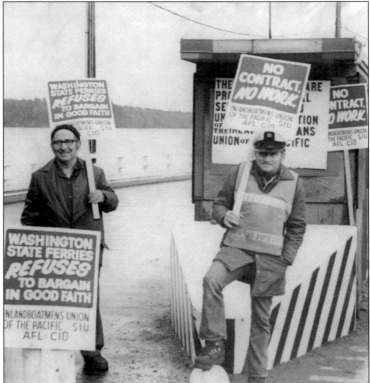

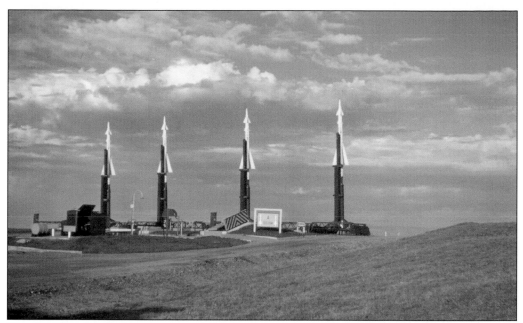

The Cold War impacted Vashon-Maury: Albert Canwell, Washington State's version of anticommunist demagogue Joseph McCarthy, was invited to speak on the island; ground observer posts were reestablished; Air Defense Battery C was stationed on Vashon; Benjamin Wilson of Vashon was awarded the Congressional Medal of Honor during the Korean War; and in 1955, a Nike site, part of the Seattle Metropolitan Defense Ring, was installed at Sunrise Ridge and Paradise Park.

In the mid-1950s, Bill Beymer and Keith Putnam led an effort to develop a scenic overlook at Inspiration Point. King County approved this project, with its spectacular views north across Quartermaster Harbor and Burton Peninsula and southwest across Maury Island to Mount Rainier. Vashon Garden Club volunteers (above, 1958) landscaped and beautified the site. The views are now largely hidden by second-growth forests.

Vashon schools saw unprecedented growth and support during the postwar years. The baby boom pushed enrollments to their highest levels yet, and school levies passed with 94-percent approval in 1947 and 75-percent approvals throughout the 1950s. With consolidation into a single island district in the 1940s, a new elementary school was constructed in 1953 in Vashon (above, 1991) on Vashon Highway north of Vashon town. Also, in 1954, a new elementary school was built in Burton (below) on the west side of Vashon Highway and above the south bank of Judd Creek. Both were demolished in the first decade of the 21st century, thus continuing the island's tradition of demolishing old schools. Vashon's old site now houses the private Harbor School, and Burton's is a skate park. (Above, *Vashon-Maury Beachcomber.*)

In 1949, the Vashon School Board purchased land adjacent to Union High School that would become the McMurray and Chautauqua sites and create a centralized campus. McMurray Middle School (above) opened in 1969 to house grades six through eight. Its name honors island doctor Frederick McMurray. In 1972, the state approved funds for the new Vashon High School (below), which opened in late 1973 after construction delays forced double shifts held at McMurray for the first three months of school. These costly delays, controversies over "frosh initiations," and food fights in the cafeteria all led to failures of school levies—for the first time since before World War II—in 1973 and again in 1974. Again, in keeping with Vashon tradition, the old Union High, built in 1930, was demolished, leaving just one wing of the original building.

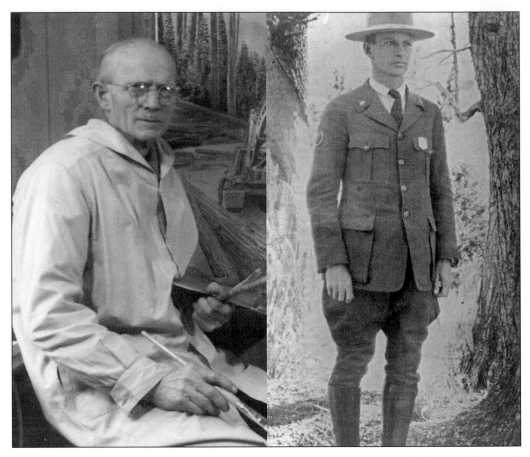

Many distinguished artists have lived on the island. Clarence Garner (above, left) painted historical logging scenes. In 1925, the Washington State Capital Museum bought 25 of his paintings, which are now owned by the Washington State Historical Society. Edmund Sawyer (above, right) lived here because it was a haven for bird life. A former Yellowstone naturalist, Sawyer was widely known for his paintings of birds in their habitat. In 1952, watercolorist, etcher, and lithographer Art Hansen (below, far left) won a Pulitzer Prize for his work. Now a member of the Smithsonian Associates Art Collectors Program, his work is held in both public and private collections. In 1982, a group of island potters (below, right) held the first Potters' Tour, opening their studios to the public. This became the semiannual Vashon Island Art Studio Tour. (Below left, Jenn Reidel.)

Bill Speidel (above, left), a former journalist, founded Seattle's Underground Tour and wrote, among many others, *You Can't Eat Mount Rainier* (1955) and *Sons of the Profits* (1967). Betty MacDonald's (above) most famous book is *The Egg and I* (1945), but she also wrote *Onions in the Stew* (1955) about Vashon and the Mrs. Piggle Wiggle series for children. Marjorie Stanley (below, left), a Vashon librarian, wrote a column for the island paper, published several books of poetry, was an authority on local history, and supported the local literary scene. Vashon native Roland Carey (below, right), historian and steamboat authority, published a revised and annotated edition of Oliver Van Olinda's *History of Vashon-Maury Islands* (1985) called *Isle of the Sea Breezers* (1976) about life on Vashon. He also wrote other local maritime histories. (Above left, Paul Macapia.)

The transition to island-wide clubs continued as islanders returned to normal life in the postwar era. Vashon Heights Community Club formed in 1946 but disbanded in 1971 and sold its clubhouse to the Grange. The Kiwanis Club formed an island chapter in 1946. Quartermaster Yacht Club (above, 1977) organized in 1947, began developing moorage, and later built a clubhouse. Today it has moorage for 92 boats and a highly successful youth summer sailing program sponsored jointly with Vashon Park District. The Vashon Island Ministerial Association was established in 1948 with participation from seven island churches. The Soroptimist Club (below, charter members) began in 1954 with the objective of advancing the status of women. The Eagles Aerie was founded in 1958 with 86 charter members.

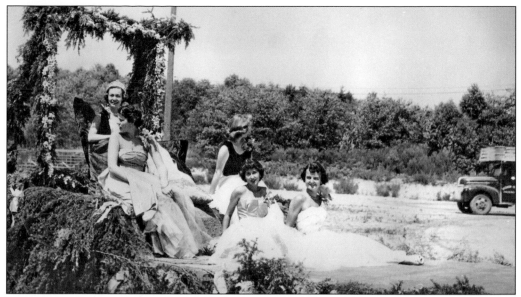

The annual island festival went though many name changes— Strawberry Festival, Peach Festival, Harvest Festival, and Island Festival—but it came close to disappearing when it lost Vashon Chamber of Commerce support in 1958 due to a "lack of enthusiasm." Festival parades had elaborate floats (above, 1953). By the mid-1970s, the festival was renamed the Vashon Strawberry Festival, and it continues revitalized ever since. With the arrival of the counterculture, the festival began to shift away from the traditional floats toward more quirky entries such as the Thriftway Shopping Cart Drill Team, Vashimba Marimba Band, and other equally diverse community groups. The children's parade (below, 1955) has often been a part of the festivals.

The counterculture revolution of the late 1960s and 1970s hit Vashon-Maury hard. The island was an ideal place for hippies to congregate. As a sheriff's deputy noted at the time, there were lots of old farms and houses that were inexpensive to rent and offered an opportunity for hippies to return to the land. The "Jesus barn" became a symbol of this new culture when hippies living in the old Sherman house in Paradise Valley painted the word Jesus on the barn. It collapsed in 1983. When a rock concert was planned in May 1971, some islanders, fearing another Woodstock, organized a volunteer sheriff's auxiliary and requested permission to carry guns. After several meetings and acrimonious debate, the auxiliary was abandoned, leaving hard feelings between the hippies and the more conservative residents of the island community. In 1974, Sound Food opened as a cooperatively run alternative restaurant and provided opportunities for many employees to start their own businesses. In 1974, even topless dancing came to the island.

THE VASHON-MAURY ISLAND
BEACHCOMBER

Telephone HOward 3-5393 P.O. Box 146, Vashon, Wash.

In 1919, the two island newspapers merged to become the *Islander News-Record*, which was the only paper until the fledgling *Vashon-Maury Island Beachcomber* began publishing in 1957. A year later, the *Beachcomber* purchased the *News-Record*, thus becoming the primary paper. Owners Carl Nelson and John VanDevanter commissioned island artist Jac Tabor to design a new masthead (above), first used on July 3, 1958.

Of many businesses established after the war, perhaps the most significant was K2, which grew to be the island's largest manufacturing plant. Started in 1946 as Kirschner Manufacturing Company, it produced reinforced plastic products. Owner Bill Kirschner developed a fiberglass ski that began commercial production in 1964 (above). Business peaked in 1999, and by 2006, the company moved production offshore and its headquarters to Seattle.

COMMUNITY DEVELOPMENT STUDY

'Operation Jigsaw'

Public Education
By Planning Group
To Start Monday

For the first time, Vashon-Maury islanders developed organized plans for their future. The first effort was the 1952 Vashon Island Report. In 1964, the first comprehensive plan, Operation Jigsaw (above, in an early *Beachcomber* headline), called for concentrating development in Vashon town. The Vashon Civic Assembly, a precursor of the Vashon-Maury Island Community Council, grew out of Operation Jigsaw to become the island's official advisory voice to the King County Council.

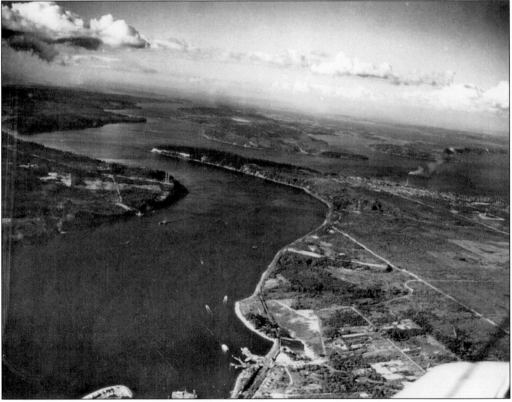

The county Open Space Initiative (1979) purchased farmland development rights to preserve the island's rural character. The first concerns about pollution on the island came when agencies tested the soil for arsenic and found significantly elevated levels. Consequently, the nation's first arsenic emission regulation was proposed, and the Asarco smelter in Ruston (shown looking north with plume visible) submitted a compliance schedule to reduce contaminants. (Tacoma Public Library, Richards Studio D8245.)

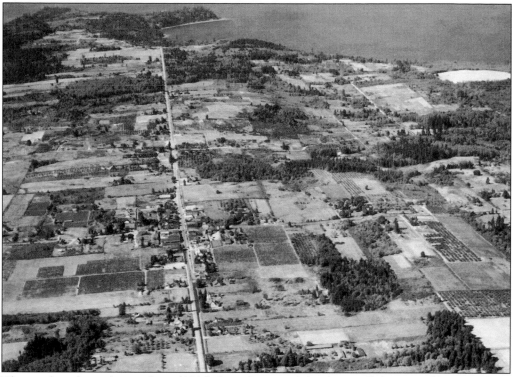

The north end aerial view above (1946) shows how much land was still dominated by agriculture and how hard it was to identify the little town of Vashon along the main highway. Though an urban street numbering system was imposed on the island by King County in 1953, it was not fully enforced. In the 1980s, many historic road names were adopted. Today, all streets have designations, and all houses received numbers in 1990. Another harbinger of change was development of the King County sanitary landfill in 1948. A decade later, the subdivisions of Patten's Palisades, Gold Beach, and Sandy Shores appeared. In 1954, Harlan Rosford (below, in his familiar bus) purchased Island Transit, and he provided bus service to Seattle until he retired in 1980. This service was incorporated into Seattle Metro in 1972.

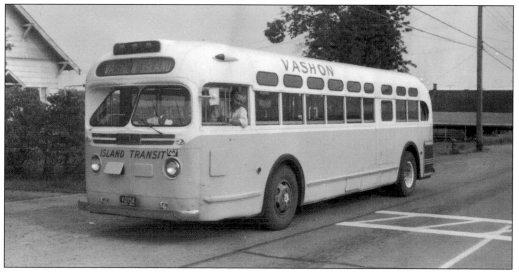

Joe Rand and his real estate sign (above) provide a mid-century portrait as eloquent as King County's 1954 Vashon Island Report. Of commuters, 38 percent went to Vashon town, 10 percent to Duwamish, 4 percent to West Seattle, and 37 percent to other areas. Islanders' spending was divided in the following manner: 44 percent off-island, 38 percent in Vashon, 12 percent in Burton, 4 percent in Center, and 2 percent each in Dockton, Cove, and Ellisport. Some 83 percent of island families owned one car and only 17 percent owned two. In 1950, dial telephone service began. There were 1,000 phones and 14 operators. In 1956, Vashon State Bank, founded in 1909, was sold to People's Bank, and the old bank building on the northwest corner of the main intersection was torn down (below, 1961) after a new bank building was constructed behind it. Little League baseball also began on Vashon in 1956. (Above, Rand family.)

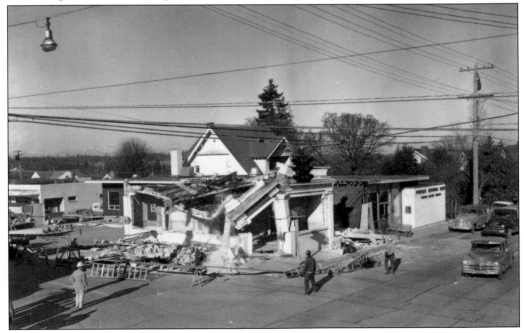

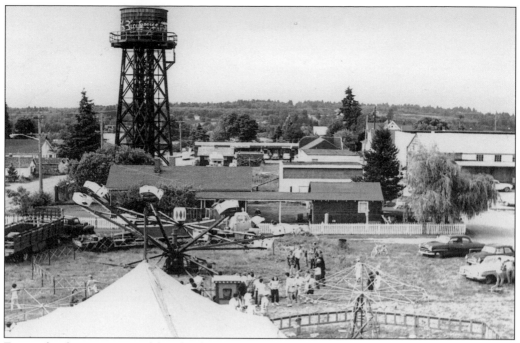

Except for the water tower (above), which was removed in the early 1970s, Vashon began to look more like it does today. A new movie theater opened in 1947, and Jac Tabor painted its interior murals in 1952. The sewer district was approved (1947), streetlights were installed (1952), and the last log cabin on main street was moved (1954). That same year, Dairy Queen opened in a small cinder block walk-up that was only open three months each year. The biggest changes came when the new Kimmel's Shop-Rite Shopping Center opened (below, 1959) and the new Thriftway Shopping Center opened in 1961. King County, using Forward Thrust funds, built Ober Park (1971) with its then-controversial "mounds." The vacant house next to People's Bank was demolished (1972), and the site later became the Vashon Island Growers Association's Saturday market.

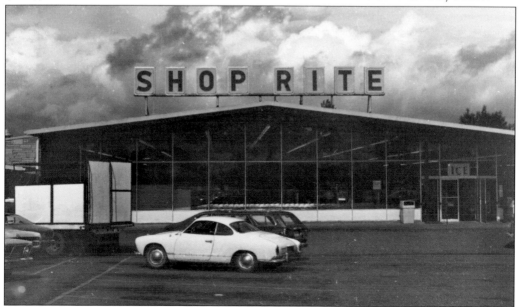

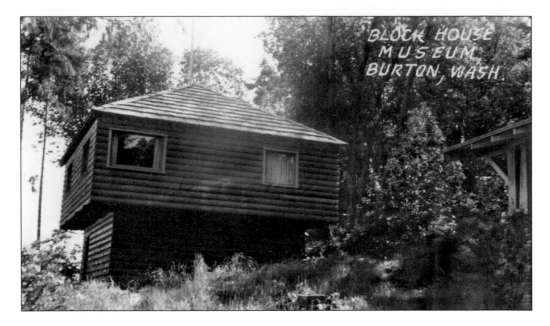

Lynne Waynick, an amateur ethnologist, collected numerous Indian artifacts, which he displayed in his Blockhouse Museum just north of Burton (above). His collection is now held at St. Martin's University in Lacey, Washington. Puget Sound tribes struggled with the state over Indian fishing rights until the Boldt Decision of 1974 recognized their treaty rights to one-half of the salmon runs. Bill Hewitt of Vashon opened Tillicum Village on Blake Island in 1962. Two Vashon families enjoyed a long association with this enterprise. Winnefred David (below, left) developed the signature salmon feast, and her husband, Hyacinth, demonstrated carving. Originally from British Columbia, the Davids worked at Wax Orchards before going to Blake Island. Max George, a former longtime Beall's employee, also cooked salmon over the traditional cedar fire while his wife, S'Homamish elder Nellie George (below, far right), demonstrated basket weaving.

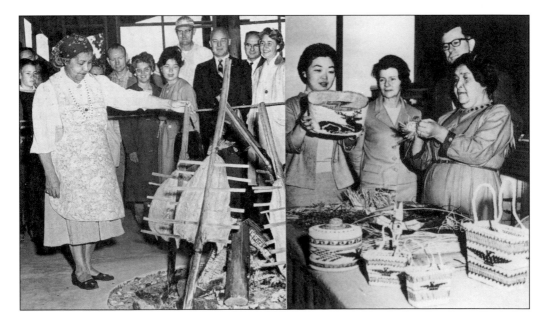

Six

MODERN VASHON
1980–2010

At the end of the 20th century, modern Vashon-Maury was a rural enclave within the urban sea of the developing Pugetopolis. Gentrification, deepening class divisions, population growth spurred by double-decked and walk-on ferries, hyperinflated housing prices, and a growing conflict between development and preservation interests have created a struggle to determine what the character of the island will be. While in the past Vashon has always defined itself in terms of its future, today many seek to define its character by its past.

The nearly 30-percent growth rate of the postwar decades through the 1980s slowed to less than 10 percent in the 1990s, and the 2010 population of 10,624 is only 5 percent above the 2000 figure of 10,123. New hidden populations of people who are gay, lesbian, Latino, homeless, and poor coexist with retirees, dot-com professionals, and white-flight urbanites. These diverse groups all bring a new kind of community to the island.

The story of Vashon-Maury at the beginning of the 21st century is one of fulfillment of the trends and patterns that created and transformed the island throughout the 20th century. There is now a highly regarded artists' community with numerous active arts organizations and individual artists. The economy has shifted from natural resources to human resources. Vashon-Maury's major export is no longer lumber, strawberries, or skis—it is intellect, as islanders commute to jobs all over the world. Agriculture is now practiced in the form of small subscription and specialized farms.

While the island prides itself on being unique, the population now turns to state and federal governments to support efforts to preserve the island against a massive mining expansion, potentially devastating oil spills, and the untempered development that characterizes mainland shores.

The modern island's population is clearly one with a group identity as opposed to the isolated water-based communities of the past. Today, its iconic Bicycle Tree represents Vashon-Maury Island's uniqueness.

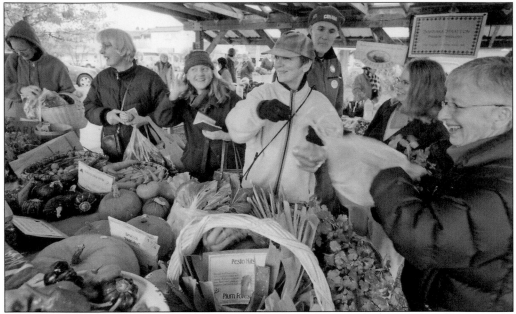

After a long hiatus, farming has once again become a notable part of the island economy. It is a very different kind of farming than that which dominated into the 1930s. Large-scale farming has disappeared and been replaced by smaller operations that rely on subscriptions, specialty crops, smaller greenhouse complexes, and direct sales to the public through, for example, the popular Vashon Island Growers Association Saturday Market (above). Wine grapes have a long tradition on the island, dating to the Hake Winery on Maury. Under the leadership of Ron Irvine of Vashon Winery (below, 1992), a group of island wineries has emerged in the past 20 years that imports grapes grown elsewhere to produce Vashon wines. (Above, Ralph F. Moore; below, *Vashon-Maury Beachcomber*.)

Conserving Vashon-Maury's environment became a priority once so much was lost that it needed protection, and in the 1980s, islanders began preservation efforts. Federal and state regulations, such as the Clean Air Act (1963), the Endangered Species Act (1973), and the Clean Water Act (1977), also helped. When voters approved the Vashon Park District in 1983, the island began to take control of its set-aside recreational space. Pictured in 1986 inspecting the first acquisition, Lisabeula Park, are, from left to right, King County Council member Paul Barden with park board members Ruth Anderson and Dick Bain. Though the Sportsmen's Club has sponsored an annual fishing derby since the 1930s, fishing is now largely a recreational sport. In 1986, Jackie Kimmel (right, with George McCormick) won the derby with a 30-pound salmon.

The struggle over expansion of Glacier's gravel mine on Maury symbolizes the conflicts concerning growth and development on the island. Opposition by Glacier's neighboring landowners quickly coalesced into a bitter fight about the appropriate scale of growth. When part of the area was declared the Maury Island Aquatic Reserve in 2004, the dispute between Glacier and a citizen's organization called Preserve Our Islands regarding the key issues of endangered species and water quality became a long, drawn-out political battle that ended in 2010 with the site becoming a county park (above). Islanders (below, forming a killer whale in 2009) protested the proposed expansion's interference with herring spawning grounds, which support the salmon runs that feed Puget Sound's orca pods. (Above, *Vashon-Maury Beachcomber*; below, photograph © Ray Pfortner/RayPfortner.com.)

The school district realized its long-held dream of a central campus when Chautauqua Elementary School opened on district land adjacent to McMurray Middle School and Vashon High School in 1994. The new elementary school combined Vashon (1953) and Burton (1954) Elementary Schools. The 1,500-student district now faces a shrinking population, which impacts funding. Still, students often score in the top 10 percent on statewide standardized tests. (*Vashon-Maury Beachcomber.*)

Catholic Croatian immigrants came to work at the Dockton drydock in 1892. Their first permanent church, St. Patrick's (above), opened in 1923. The drydock bell was added in 1960. With population expansion on Vashon, St. John Vianney opened in 1964 and became the official parish seat. In 2001, St. Patrick's became a chapel, ending 78 years of Sunday services.

A quiet revolution took place in the 1980s and 1990s that increased ferry capacity by 40 percent and had a profound effect on the island. On the north end run, the old Steel Electric class 78-car ferries were replaced by two 87-car Evergreen State class ferries and a 124-car double-decked Issaquah 130 class ferry (above). At Tahlequah, the 34-car *Hiyu* retired, and the 64-car *Rhododendron* took its place. When passenger-only service began in 1990 (below), which offered direct service to downtown Seattle, it allowed an urban-based commuter population to swell the already substantial number of commuters living on the island. Between 1980 and 2010, a full 3,835 residents joined the island community—nearly the same number of total residents in 1950. Recent reductions in service and rises in rates have once again pitted islanders against the ferry system. (Above, Terry Donnelly; below, *Vashon-Maury Beachcomber*.)

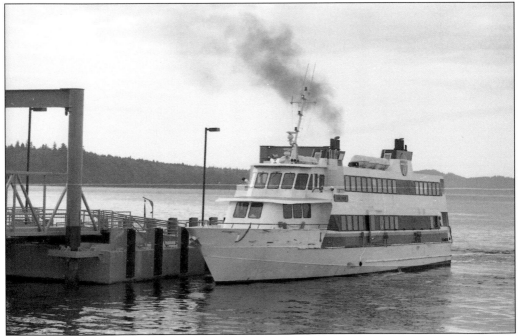

The ferry revolution also brought a revolution in bus transportation. Metro, which had saved Lake Washington, was chartered to build a regional bus system. The response created various options for bus transportation to Seattle and other major employment centers. Buses (above) met most ferries and at peak commute times offered a direct ride to or from downtown Seattle. When the population grew due to ferry and transportation changes, a new demographic of urban escapists, professionals, and retirees shifted island attitudes. The Vashon bridge issue did a 180-degree turn. In 1992, when the Washington State Department of Transportation held hearings on constructing a bridge, more than 2,000 islanders attended, carrying signs reading, "If You Build It, They Will Come" and "Don't Mercerize Vashon Island" and sporting a logo (below) designed by local artist Nancy Silver. (Above, *Vashon-Maury Beachcomber*; below, Nancy Silver.)

Vashon
Community Plan
Profile

An increasing population put pressure on planning efforts, government agencies, and local service organizations, yet the island seldom took the initiative to develop plans for its own growth. Instead, outside forces like the state's Growth Management Act (1990) and the county's Critical Areas Ordinances (1994) have had more impact on controlling development. The Vashon Community Plan (above, 1978) was adopted in 1981, revised in 1986, and revised again in 1996 as the Vashon Town Plan. Since 2000, these plans are revised on a four-year cycle and have provided direction by identifying key issues, including managing water, ensuring affordable housing, and controlling and maintaining the rural nature of the island. The Vashon-Maury Island Community Council (below, 2004) serves as advisory to the King County Council. The 2010 board resigned en masse in a dispute over the state's open meeting law. (Below, *Vashon-Maury Beachcomber.*)

The state's Growth Management Act required that plans take into account the impact of growth on ecosystems and mitigation efforts that would protect the environment. In 2004, King County Council approved the Critical Areas Ordinance, which limits rural development, requiring that regulations be based on the "best available science." Both of these policies were met with resistance by those favoring development and those supporting preservation of island ecosystems. Water was the primary issue, both potable systems and septic disposal, as seen above with a septic tank of "Vashon Island's No. 1 Export" being maintained by Niece Pumping Service. A concomitant dilemma is the "McMansion issue;" Islanders continue to debate whether there should there be limits on the size of island homes. Below is the entrance to one of the island's large estates.

The irony of farmers felling forests to make land available for sustainable agriculture and caring for the land is not lost on islanders today. The Land Trust led environmental preservation efforts when it organized in 1989. In 1991, it acquired Whispering Firs Bog, where the ecosystem is so vulnerable that public tours are only offered once annually. Pictured above is one such tour led by Tom DeVries, center, in 1995. Pictured below, Yvonne Kuperberg, with County Executive Ron Sims, left, and Councilman Dow Constantine, accepts a 2005 Lifetime Achievement Award from King County for her late husband, Joel, at a ceremony in Island Center Forest. The Kuperbergs supported protection of the Island Center Forest, among many other projects. Forest Stewards, Audubon, Wolf Town, Preserve Our Islands, Sustainable Tourism on Vashon, and many other organizations also support preservation. (Above, Jay and Rayna Holtz; below, *Vashon-Maury Beachcomber*.)

Clearly identifying what makes Vashon-Maury unique is difficult. In many ways, the island is little different from numerous other small communities around the Salish Sea. Yet unique it is, as symbolized by the Bicycle Tree, which is as illustrated above by former island resident Berkeley Breathed in his book *Red Ranger Came Calling*. A bicycle was forgotten in the forest by a boy in 1954, and a fir tree grew up around it. A sense of community was also developed through efforts such as the 1995 drive to save Island Manor Nursing Home and create in its place the nonprofit Vashon Community Care Center (below). Now a state-of-the-art facility, it offers multiple levels of services to inpatients and outpatients alike. (Above, from *Red Ranger Came Calling* by Berkeley Breathed, © 1994 by Berkeley Breathed, by permission of Little, Brown and Company, reprinted by permission of International Creative Management, Inc. © 1997; below, Terry Donnelly.)

In the decades since 1980, several separate populations with their own special characteristics have settled on Vashon-Maury. A large gay and lesbian population is present with many established couples integrated into the general community. The business sector has two Mexican restaurants and a *tienda* (above) that caters to the Latino community. Low-income, homeless, and marginally or under-employed people also live on the island. Vashon HouseHold (below, 1990) was formed to address the need for low-income and subsidized housing through its complexes, which include Vashon Co-Housing, Sunflower, Roseballen, Charter House, J.G. Commons, Eernisse Apartments, and Mukai Commons. These supply 132 houses and apartments. Without this help, many working-class residents and senior citizens would otherwise be forced to move off-island. (Below, *Vashon-Maury Beachcomber*.)

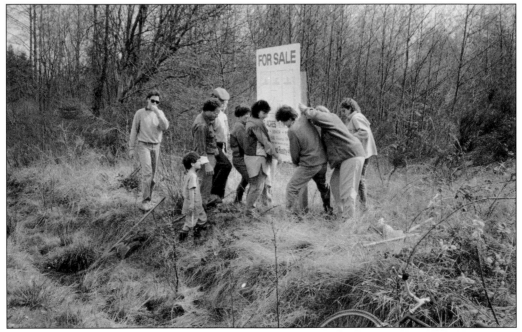

KEEP VASHON WEIRD

In the early years of the 21st century, two bumper stickers appeared on island cars and trucks. "VSH" (Vashon) indicated the vehicle's origin and "Keep Vashon Weird" reflected a growing concern about maintaining the island's distinct identity. But just what was it that islanders sought to preserve? Stoplights, franchises, library locations, performance spaces, schools, a gravel mine, ferry service, water rights, mega-mansions, affordable housing, commercial development, and electronic signs with LED display lights (below) have all created controversy. As novelist David Gutterson remarked about the nearby island where he lives, "An island is, like Earth itself, a small promise in an endless sea." (Above, Vashon Merchants Association.)

Championing causes from AHOPE for Children to Wolf Town, the 10,624 islanders of Vashon-Maury have a rich assortment of 156 nonprofits, several dating from as early as the 1940s. Notable in the vital and varied arts community is Vashon Allied Arts (VAA), which was founded in 1966 and is one of the oldest community arts centers in Washington. It supports visual arts, music, dance, theater, writing, pottery, quilting—virtually any art form imaginable. Above, the women who established VAA's various arts programs gather at the 40th anniversary celebration in 2006. Other arts groups like Islewilde, Drama Dock, Vashon Island Chorale, Vashon Youth Ballet (pictured below in 2004 during its annual *Nutcracker* performance), and many others also provide artistic outlets and entertainment. (Above, John Sage/FinchHaven; below, *Vashon-Maury Beachcomber*.)

When the Vashon-Maury Health Services Center started in Burton, a group of volunteers first served as receptionists and then organized to raise funds to support the center. The thrift store idea caught on, and Granny's Attic (above, 1993), now with 10 employees and 80 volunteers, has been in its current location at Sunrise Ridge since 1975. Founded in 1991, Vashon-Maury Community Food Bank (below) has a large year-round garden and is piloting a farm project to supplement its donations and support 200 families each week. Seniors and children make up two-thirds of its clients. Numerous other nonprofits, including Vashon Be Prepared, Rotary, Soroptimists, and Vashon Island Pet Protectors, support the island's needs. (Both, *Vashon-Maury Beachcomber*.)

Some specialized businesses are suited to a ferry-dependent rural enclave. One, known locally as the Bone Factory—though its sign says Sawbones (above)—is a division of Pacific Research Laboratories. Founded in 1978, at 70 employees it is the island's largest manufacturer, making artificial bones and other materials for surgical training. Island Spring, located south of town, has produced tofu-based products since 1976. Olympic Instruments, formed in 1946, makes wire and cordage measuring devices. More traditional is the Country Store (left), opening in 1964 and adding a plant nursery when it moved to its present location in 1980. Numerous consultants, telecommuters, and other off-island–focused businesses support the variety of shops and services that make up Vashon-Maury's retail core. (Above, Pacific Research/Sawbones; left, the Country Store and Gardens.)

The French philosopher Jacques Derrida developed the concept of "phantom cultures" that remain in the postcolonial world as ghostly cultural presences whose memories and artifacts remain long after the original has disappeared. Vashon has its own phantoms, where brickyards, shipyards, drydocks, logging mills, and productive farms once stood. Two of the most visible phantoms are the abandoned crumbling greenhouses of the Beall company (above with Tom Beall Jr.) and the abandoned production plants of the K2 Corporation (below). They occupy the collective memory of the island and are reminders of past glories and the transient nature of success on a ferry-dependent island. (Below, Terry Donnelly.)

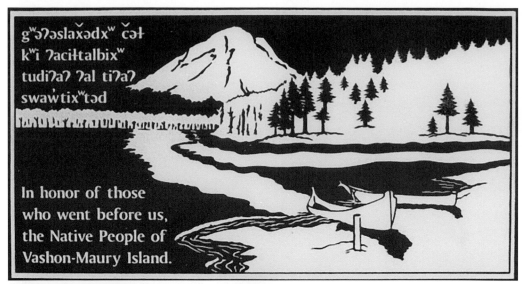

gʷəʔəslax̌ədxʷ čəɬ
kʷ'i ʔaciɬtalbixʷ
tudiʔaʔ ʔal tiʔaʔ
swaw'tix̌ʷtəd

In honor of those
who went before us,
the Native People of
Vashon-Maury Island.

While the S'Homamish were officially removed from the island in 1855, their descendants continued to return for many generations. In 1996, Roxanne Thayer's students at McMurray Middle School participated in the Hands Across Time project to excavate a site at Jensen Point on Burton Peninsula. It recognized the continuous occupation of Vashon by the S'Homamish for at least 1,000 years. Today, the spirit of the S'Homamish remains in the Hands Across Time memorial (above) that recognizes their original place on the island. In the early years of the 21st century, a new Native American population has joined the community, consisting of members of various tribes from throughout the Pacific Northwest and the United States. According to the 2000 census, there were 236 Native Americans living on the island, one of whom is Tlingit master carver Israel Shotridge, pictured at left in his studio. (Left, *Vashon-Maury Beachcomber*.)

Built in 1909 as the Vashon Evangelical Lutheran Church, this building is now home to the Vashon-Maury Island Heritage Association. The association, founded in 1976 as a repository for historic island artifacts and memories, bought the building for its museum, which opened in 2003. Today, it has a permanent exhibit with research, archive, and meeting rooms. Its collection consists of more than 2,000 items and 6,000 photographs, all acquired by donation. The exterior walk is paved with bricks commemorating island names and places. This brick walk is the one moment when history coalesces and recognizes that the past is as recent as yesterday. It represents both the preservation of memories and the active present, serving as a reminder that it is important to record even recent history. The future cannot be written with certainty, but remembering past events enables one to see the trends, learn from them, and map the next steps.

INDEX

A complete name and subject index as well as a bibliography by chapter are available at www.vashonheritage.org and www.vashonhistory.com.